William Gaunt RENOIR

PHAIDON

Phaidon Press Limited, Littlegate House, St Ebbe's Street, Oxford Published in the United States of America by E.P. Dutton, New York

First published 1962 Fourth edition 1976 Reprinted 1978 © 1976 Elsevier Publishing Projects, Lausanne

All rights reserved No part of this publication may be reproduced, stored in a retrieval system, or transmitted in any form or by any means, electronic, mechanical, photocopying, recording or otherwise without the prior permission of the publishers

ISBN 0 7148 1737 6 Library of Congress Catalog Card Number: 70-141056

Printed in Great Britain by Waterlow (Dunstable) Limited

RENOIR

RENOIR . . . the name of the great French painter (in itself like a sigh of pleasure) calls up an entrancing world in which the women and children are entirely captivating, the sun-flushed bathers, splendid of body, seem to belong to a new golden age, the landscapes shimmer with intoxicating light and colour, the everyday scene the artist knew is endowed, by his perception, with a wonderfully joyous and gracious life.

He is born into the nineteenth century, yet he has banished from it all that is stern and sombre, awkward and ugly. This is the effect of a temperament, an outlook, he shares, in some degree, with other members of that remarkable group with whom he is associated, the Impressionists, whose concurrence is so beautiful an episode in the history of art. His creativeness, however, is not confined by the formulas of a 'movement'. He is like an artist of the eighteenth century, of the time of Boucher and Fragonard, reborn in the bourgeois epoch. He admires and conserves, it is the nature of his gift to express, the exquisite refinement of the French tradition. On the other hand he marches forward into the twentieth century, his art in his old age, when, though crippled in body, he is more vigorous than ever in spirit, puts out new and rich blooms.

To trace this magnificent evolution let us first mentally transport ourselves to Paris of a little more than a hundred years ago and enter the workshop of a china manufacturer in the rue du Temple.

Here, in 1854, sat Pierre-Auguste Renoir, a slight, brown-eyed boy, thirteen years of age, industriously painting sprays of flowers on the smooth white surface of cup and saucer. It was his start in life, for which he had to thank the peculiar respect the porcelain industry inspired in his parents. They came from Limoges, where porcelain stood for prestige and prosperity. In their view it offered an ideal niche for a son who wished to be an 'artist'. The father of Pierre-Auguste, Léonard Renoir, was a 'modest artisan', a struggling tailor, that is, who had been unsuccessful in Limoges and in middle age had come, with wife and children, to try his luck in the capital. Pierre-Auguste was born in Limoges in 1841, but as the move was made when he was only four he had no memories of his native city and never again set foot there.

To all intents and purposes he was a young Parisian of the working class. It would seem that the first known Renoir of the line (Francis) was a foundling, but born in 1773, married in the revolutionary Year IV (1795), becoming the father of Léonard in the Year VII. The first impressions of our Renoir were of humble quarters in the rue d'Argenteuil. He went to the state school, where the choirmaster of St Eustache, Charles-François Gounod, who gave music lessons (he was not yet famous as a composer), picked him out as one with the makings of a singer: but the symptom familiar in the early life of most artists showed itself. He covered the pages of his exercise books with drawings; his parents gave his bent as practical a turn as possible and in the rue du Temple he made his début as a kind of painter.

It was not work of a high order; the decoration of the pieces (intended for export to eastern countries) was paid for at the rate of sixpence a dozen. Nevertheless it required and fostered a precise use of the brush, a delicate touch and an appreciation of quality in the glaze of bright colour on its smooth white ground. For four years the young Renoir was an industrious apprentice in the art and craft of porcelain painting, progressing in design from the simple flower to the portrait of Marie Antoinette. It gave him, no doubt, the pride of craft. Something of its fine technique remains, or reappears, in his mature style; yet other and greater influences were already at work. The rue d'Argenteuil was near the Louvre and he slipped in as often as he could to gaze at its masterpieces. Released from the factory at lunchtime, he discovered one day the *Fontaine des Innocents* by the sixteenth-century sculptor Jean Goujon and walked slowly round and round it (absent-mindedly chewing his morsel of *saucisson*) absorbed in the grace of the sculptor's conception, the solidity of form that yet allowed one to see the very grain of the flesh. It was at the age of seventeen that he gained a special intimacy with the elegant court painters of the past.

At this moment the introduction of printed designs on pottery drove Renoir's employer out of business – a sharp lesson Renoir never forgot in the enmity between modern industry and handicraft. He took to painting fans for a living, with copies of pictures from the Louvre by Watteau, Lancret, Boucher and Fragonard. Time and again he reproduced the gallants and ladies in the rich landscape of Watteau's *Embarking for Cythera*. All his life he was to love Boucher and Fragonard, in whose joyousness of feeling he now discovered an affinity with his own feelings as an artist. How well Boucher understood the beauty of woman, the softness of contour, the suppleness of limb.

These loyalties throw a light on the mature work of Renoir which makes it easier to understand why he has been called 'a great eighteenth-century painter born a hundred years late'. In spirit, the youthful painter of fans already belonged to the vanished age of elegance, though between the ages of seventeen and twenty-one he had to find his way through a good deal of modern drudgery. For a long time it seemed impossible to be a real painter. A fellow-worker in the porcelain factory who dabbled in his leisure hours had encouraged him to take to oils and canvas and had spoken with warmth to Renoir's parents of the result, but the francs had somehow to be brought in by other means. In addition to the fans, he copied or adapted some heraldic designs for his elder brother, a graveur en médailles. He decorated a café. Finally he got a job with a manufacturer of window blinds who supplied missionaries with material, painted to imitate stained glass and thus give to some hut in the tropics the illusion of a church interior. He saved money enough to live on for a while and take up the study of painting in earnest. At the prompting of his friend Laporte he decided to go to the Atelier Gleyre: and there at the beginning of the 1860s he made his real start.

It was a free and easy institution, this atelier of Charles Gleyre, a mediocre Swiss painter who had taken it over as an art school from another mediocre painter, Delaroche. The teaching was casual; once a week or a fortnight, the morose and ageing master put in an appearance and made his brief, weary comments. To Renoir, he observed, on one occasion, 'One does not paint for amusement,' which called forth the retort, 'If it didn't amuse me, I shouldn't paint.' In this exchange both were true to character. Gleyre, the follower of Ingres, regarded painting as a severe and formal exercise: for his pupil it was, and always remained, a pleasure. As they had nothing in common, Gleyre could be no help, and his merit, from Renoir's point of view, was that he left the student to his own devices. For the discipline of drawing Renoir went of an evening between 1862 and 1864 to the Ecole des Beaux-Arts: yet the Atelier Gleyre was by no means useless. It had two great advantages. It was a meeting place of youth, talented, ambitious, energetic. Renoir there formed those friendships, with students of about his own age, that had a very great influence on the development of his art. The second, and related, advantage of Gleyre's was that new ideas passed to and fro. The atelier itself seemed to encourage them, in reaction against its own lifeless canons.

The intimates of Renoir were three: Claude Monet, Alfred Sisley and Jean-Frédéric Bazille. He could have found no livelier or more gifted company. Monet was already interested in the problem of bringing a new truth of atmosphere and effect into landscape. Sisley, the well-to-do young Englishman born in Paris, shared his interest in landscape (his great enthusiasm was Corot). Bazille, who came from Montpellier, where he had been a medical student, was likewise the admirer of the new nineteenth-century art with its striving towards reality.

It was now that Renoir became aware – of the French Revolution. It intervened like a wall between his age and that of Boucher and Fragonard. On the nearer side of it tradition had withered, grown lifeless and false. Renoir ranged himself on the side of those post-Revolutionary artists who had defied scholastic precept – with Delacroix, who had burst through cold restraint to paint with emotion; the landscape painters of Barbizon who, inspired by the English Crome and Constable (though this the young students of Gleyre may not have realized) looked at a tree for themselves; with Courbet, the unflinching realist.

It is, broadly speaking, as a realist in the manner of Courbet that Renoir, in his twenties, first comes into view as an artist; though other influences can be discerned. He tried, apparently, a romantic subject, in his first Salon picture, the Esmeralda of 1863, but this he afterwards destroyed. He used the cool grey of Corot. He learned also, by his own account, something about colour from the Barbizon painter Diaz. 'Why on earth do you paint things so black?' said Diaz, who chanced upon Renoir and Sisley in 1862 on a sketching expedition in the forest of Fontainebleau. It was, however, with Courbet's eye for fact that he painted the group At the Inn of Mother Anthony in 1866, depicting the village inn at Marlotte just as it was, with the servant Nana, the dog Toto, and the wall decoration contributed by various habitués (Renoir himself added the caricature portrait of Murger on the left), introducing also his painterfriends, Sisley and Jules Lecoeur. It is a document of the sixties: as frankly as Courbet, Renoir accepted the unbeautiful male costume of the time. It offered its problem once more in the picture of Sisley and his wife painted in 1868, though in this there is a charm that derives from the artist's vision, the sense of an even poignant contrast between the human and natural pose and the cumbrous dress that fashion has prescribed, a lightness of touch that turns the shapeless trousers and the weighty crinoline to decorative advantage.

'Courbet was still tradition, Manet was a new era of painting.' Thus Renoir was later to define the brilliant man who finally resolved the camp of young realists into a creative group, engaged not only in painting contemporary subjects but in giving a fresh life and intensity to the medium they used. It was long before Renoir was entirely weaned from the massive influence of Courbet. There is still a reminder of it in the 'Baigneuse au Griffon' (Plate 5), painted when Renoir was twenty-nine; and even later. Yet in the meantime other forces were at work. If Renoir was inclined by nature to suspect the 'new', yet like his friends he could not fail to be excited by the revelation of Manet's Picnic in the Salon des Refusés of 1863, the Olympia of 1865. Here was the challenge of contemporanéité (to use Manet's word) suggesting, if not as yet fully embodying, so many things, a method of startling directness, a release of the powers of colour and light. The younger contemporaries of Manet drew closer together, to discuss and defend him, to develop their own ideas in the light of his. It would not seem that Renoir took any notable part in those famous discussions at the Café Guerbois which led or helped to lead from the championship of Manet to the theory of painting in the open and translating light into broad divisions of primary colour. Yet he was touched by the same enthusiasm as Monet and Bazille, by that of more recent friends, Camille Pissarro and Paul Cézanne, whom he first met in that great year of refusal, outcry and debate, 1863. He absorbed something of the character that now began to distinguish them as a group. The follower of Manet appears in the Skaters in the Bois de Boulogne, 1868, with its bold, direct strokes of the brush: and so closely was he associated with Monet in these years that inevitably their pictures began to show points of likeness.

He and Monet painted together in the open air, with the patches of pure colour that proved so wonderfully effective (according to the recipe Monet himself had largely devised) in conveying the shimmering effect of atmosphere. They sat side by side in 1869 at the bathing-place on the Seine, La Grenouillère, studying the overhanging trees, the gay crowd of holiday-makers. The pictures that Monet and Renoir have left of the scene (Plate 6), from almost the same point of view, are gay, idyllic. For Renoir, the warm summer afternoons spent on that long curve of the Seine, on the outskirts of Paris at Bougival, Croissy, Chatou, were unmixed happiness. Summer was his season; unlike Monet, he could not interest himself in any other time of the year. 'Why', he once asked, 'paint snow, that leprosy of nature?' It was better to look at the sunlit Seine, *en fête*, its fascinating medley of people, sauntering in the open or enjoying themselves in the floating restaurant. There were superb girls among them, who could, without much difficulty, be persuaded to sit for a picture.

When the Franco-Prussian war began in 1870, Renoir was a slender, hollow-cheeked young man of twenty-nine. He was not, materially, much better off than when he was doing his hackwork for the manufacturer of window-blinds. There was a gulf in this philistine century between artist and public which it sometimes seemed impossible to bridge. This had created the 'vie de Bohème' in the ways of which Renoir had become well versed: the moves from one garret to another with meagre belongings packed in a wheelbarrow, the visits to the mont-de-piété, the casual sale to some small tradesman eccentric and exceptional enough to lay down a few francs for a useless thing like a picture.

A painter could live, perhaps, on five francs a day. At the same time, the fifty to a hundred francs, which could with difficulty and at uncertain intervals be extorted for a canvas, did not go very far. The young men helped one another, they were an alliance against the world. In 1866 Renoir found food and lodging in the home of the painter Jules Lecoeur. Bazille, who was not badly off, came to the rescue at intervals. In a letter of 1868 he writes, 'Monet has dropped on me out of the blue with a magnificent lot of canvases. He'll sleep here until the end of the month. With Renoir, that makes two needy painters I'm housing. It's a real workhouse. I am delighted. There's room enough and they're both in very good spirits.' At intervals, Renoir retreated to the house of his parents, who now lived at Ville-d'Avray. He was there in 1869, together with Lise, the model with whom he was then much taken, whose Manetesque portrait with a parasol figured in the Salon of the year before (Plate 4). Monet was almost literally starving. Renoir filled his pockets with bread from the parental table to take to his friend. There were times when he felt like giving up, for it was not his nature to go against the tide; it was then that Monet, the real fighter, encouraged him to keep on. Theirs, after all, was a cheerful misery. They were young, able to enjoy themselves, devoted to their profession and conscious of unusual powers.

Renoir had as yet produced no characteristic masterpiece, though his ability from 1864 onwards could not be in doubt. The impression made on him by others was still very obvious in his work: his personality as an artist was not completely formed. In his own estimate he was just beginning to be 'known', which implied the approval of artists rather than patrons. He looked on it as a sign of progress that Manet, a fastidious critic, spoke well of his portrait of Bazille at the easel (Plate 8): but not long after he had painted it, war abruptly broke in on the life and work of Renoir and his friends, scattering them far and wide. Poor Bazille, who had shown excellent promise as an open-air landscape painter, was killed at the battle of Beaune-la-Rolande. Renoir served in a cavalry regiment though he saw no fighting, being stationed at Bordeaux. He came back to Paris after Sedan, during the confused period of the Commune, having for a time a passport enabling 'citizen Renoir' to carry on his occupation in public.

War, defeat, the end of the brilliant Second Empire, did not assist artists in finding their way to success. The Bohemian life, precarious before it, was doubly so after, and for many years. As late as 1877 Renoir found himself one day with only three francs (and the urgent need of forty before noon). In the same year he remarked to Théodore Duret (the historian of Impressionism) that he was in a fathomless mess ('un pétrin insondable'). It was in this decade that the pre-war group of friends, resuming their cooperation, were labelled 'Impressionists', thereby having to contend not merely with neglect but with an active hostility, as merciless as that which had previously assailed Manet.

At about the same time Renoir discovered, or rediscovered, Delacroix, paying his tribute to the sumptuous effect of Delacroix's *Women of Algiers* (which he was always to speak of as one of the supreme masterpieces) in a sort of free 'variation' – a painting (1870) of a Parisienne dressed as an Algerian (Plate 10). It would be fair to say that the pictures produced between 1871 and 1873 are very interesting and unequal. It took some time to pick up the threads. The 'influences' that can be separated out were valuable to his development but still to some extent hid his personality from view. By 1874 the process of assimilation was complete. Renoir the independent and individual genius emerged about the same time as the first Impressionist exhibition was held.

The question has sometimes been asked whether Renoir was really an Impressionist. Ultimately he came to adopt a standpoint very different from that of Manet, and to question many of the the tenets by which Impressionism is commonly represented; yet the closeness of his association with the movement is beyond question. He contributed, with Monet, Pissarro, Sisley, Cézanne, Degas and others, to the famous show at Nadar's gallery. When, as a result, a facetious journalist, noting several pictures entitled 'Impression', including an *Impression of Sunrise* by Monet, labelled the group 'Impressionists', Renoir obviously shared the nickname with the rest. He continued to show his pictures at the exhibitions specifically called, unlike the first, Impressionist. Later he spoke of having in 1874 'founded' – with Pissarro, Monet and Degas in particular – the Salon of the Impressionists.

It would, of course, be absurd to assume that the word made them identical. Renoir was never so 'impressionist' as Monet in trying to render truthfully the appearance of objects under a given effect of light at a given time of day: or as Pissarro in cultivating the division of the spectrum colours as a method. Painting was not only scientific observation. The purpose of a picture, he once remarked, was to decorate a wall, which made it important that colours should be pleasurable in themselves and in their relation to one another apart from other considerations.

The idea of an entirely new method aroused the suspicion of one who had practised a traditional craft. It was said, when Impressionism had become a subject of analysis. that it meant ridding the palette of black, an idea Renoir did not approve at all. Black had its own value when properly used as the great artists of the past well knew.

Certainly his first great picture, 'La Loge' (Plate 16), one of the exhibits at Nadar's in 1874, can be appreciated without much reference to the stock literary terms of Impressionism. It was not an impression of an actual theatre, but was 'made up' in the old studio fashion, a model known as 'Nini gueule en raie' posing for the woman and Renoir's brother for the man. The colour, rich as it is, depends on a contrast (in itself conventional) of warm tones and cool. The artist gives a brilliant demonstration of the depth and vividness of a black which is dominant in the scheme. The people are not seen through an atmospheric veil but stand out clearly as living human beings: in the eyes of Nini there is that extraordinary animation of which Renoir had the secret. There is even a sense of 'period' in the picture, of something not quite contemporary, as if it were a sumptuous pendant to the now historic luxury of the Second Empire. Henceforward it would seem that Renoir could hardly go wrong. His work now had an unmistakable style. It appears in a succession of beautiful pictures of women and children, possessing that peculiar charm only he could give. *The Dancer* (Plate 15), also exhibited at Nadar's gallery in 1874, has it to the full. For a moment only it recalls the ballet dancers of Degas, yet it has none of the illusionary footlight glamour that balances the latter's sharply critical sense of reality, it is a delicate and tender portrait. He paints an admirable series of nudes, delighting in the pearly and luminous quality of surface; scenes of Parisian life that give us not merely the fact but the sensation; landscapes that vibrate with triumphant colour.

He was Impressionist (as the word is now used) partly in subject, in the keen appreciation of the present, and transient, moment; partly in the great release of colour which was a means of seeing the world afresh. It was inevitable that his work should bear some family likeness to that of the other artists with whom he was associated, not merely as an exhibitor in a gallery but in a more personal fashion. The café and its discussions, however much the frequenters might argue and differ, made for a certain unity. There was a new meeting place in these days, the Café de la Nouvelle Athènes in the Place Pigalle, which had replaced the Café Guerbois in favour since the war. If Renoir was usually quiet, idly tracing scrawls on the table with a burnt match, he was in the current of an idea. Even Manet, enthroned among the artists, receiving the homage of critics and poets, so distinct an individual and of an older generation, having incited a movement became in a sense its follower. In colour and subject he tended to align himself with the younger school. The Impressionist spirit creates its affinity, between Manet's *In the Café* and Renoir's (Plate 20); the *Bar at the Folies-Bergère* by the one, the *Moulin de la Galette* by the other (Plate 28).

The habit of painting together retained its importance. With Claude Monet, back from his wartime visits to Holland and (with Camille Pissarro) to London, Renoir once more repaired to the Seine. In a boat moored at Argenteuil they worked as in earlier days side by side, and in that beautiful picture *The Skiff*, Renoir achieves a translation of light into colour as complete as that at which Monet was aiming (Plate 29). It is a curious sidelight on the prejudices from which great artists are not immune, that Manet, who joined them at Argenteuil in 1875, expressed the opinion that Renoir ought to give up painting. The modern observer on the contrary is struck by the mastery Renoir shows in the Impressionist years: the immense skill with which he places a figure in focus in '*La Première Sortie*' (Plate 17; 1876/7), and surrounds it with blurred details to create an 'impression': the resource and variety with which he explores the clarified range of colour, as in the exquisite harmonies of his *Girl with a Watering Can* (Plate 14; 1876), or the wonderful radiance of the *Girl Reading a Book* of the same year (Plate 18).

There is in the pictures of this productive decade an element of autobiography. His continued friendship with Monet is signalized by the portrait of 1872 (Plate 12), the pictures at Argenteuil. In Paris he had a studio in the rue Saint-Georges. We peep into it in the painting of 1876 (Plate 21) to see some of his friends, the circle that Georges Rivière, one of the champions of Impressionism, has described: the elegant Lestringuez on the left, a civil servant in the French Home Office; in the centre, Rivière himself with drooping lock of hair, elbow on knee; the dreamy musician Cabaner, a young painter called Cordey; and behind Cordey, the already patriarchal-looking head of Camille Pissarro (Renoir's senior by eleven years).

It was then or about then and perhaps in the company of one or other of his callers that he sallied out to look at Paris. He was fond of Montmartre and especially of the Moulin de la Galette, the popular dance hall of the working-class families of the district. As Montmartre was not yet overrun with tourists, the Moulin (which dated from the eighteenth century) had kept an old and rustic flavour. There were two dance floors, one inside and one in the garden or courtyard planted with acacias and furnished with tables and benches. Here Renoir would sit of a summer's evening, watching the family parties, and the young men and girls drinking wine or beer and eating the galette or pancake which gave the place its name. They danced for the love of it, with happy abandon. Renoir was perfectly at home. It was the people's Paris he had known from his earliest years. It had youth and gaiety: indeed, in spite of its proletarian aspect, it nostalgically recalled the fêtes of the Ancien Régime. It was the material for a masterpiece of which there are two versions, one painted in the open air and on the spot (in the Whitney collection), the other (Louvre) not materially different in grouping, but more finished, and elaborated in the studio (Plate 28).

The picture was shown in the second Impressionist exhibition of 1876 at the gallery of Paul Durand-Ruel, who had for some time been the staunch supporter of the group. He had shown the work of Monet and Pissarro in London (one of Renoir's pictures *Le Pont des Arts* was exhibited there by him in 1871); further examples in Paris; and risked his professional standing by the venture. The critics of the Parisian press were angrier than in 1874 when Louis Leroy had his little joke about 'Impressionists' in *Le Charivari*, and Renoir, who contributed fourteen works, came in for his share of their fury. They were the cream of his production, including besides the *Moulin*, '*La Première Sortie*', *Girl Reading a Book* and a remarkable nude study of *Anna*. Yet Albert Wolff, the critic of the *Figaro*, whose air of a dilettante Mephistopheles has been respectfully portrayed by Bastien-Lepage, observed: 'Try to explain to M. Renoir that the body of a woman is not a mass of decomposing flesh, with the green and purple spots that denote the entire putrefaction of a corpse.'

The exhibitions were a dead loss. So too was the sale at the Hôtel Drouot in the year between, 1875, to which Renoir sent fifteen canvases. It did not bring in enough to pay the auction expenses. Yet a circle of admirers and supporters was beginning to form. It was on the eve of the sale that Renoir met Victor Chocquet, a minor civil servant of very modest means but excellent taste, who had a passion for Delacroix and perceived in Renoir something of that master's quality. Chocquet commissioned him to paint his wife's portrait and then his own (Plate 26).

The continued interest of Chocquet in Renoir and Cézanne resulted in many more purchases. When his collection was dispersed in 1899 he had twenty-one pictures by Cézanne and twenty by Renoir. Renoir, however, was able to ascend into regions from which Cézanne, if he had been admitted, would probably have fled at the earliest opportunity, the upper bourgeoisie of the 1870s, wealthy, cultured in its own fashion, but not in general sympathetic to adventures in visual art. The Charpentiers, whom Renoir came to know, were, it is true, of special distinction. Georges Charpentier was the publisher who championed the literary 'naturalism' of the time. His wife had a salon frequented by many famous men of letters. Zola, Maupassant, Flaubert, Huysmans, Mallarmé, Edmond de Goncourt . . . the list of guests becomes an outline of literature under the new Republic. Painting, however, was sometimes represented by those of a conventional stamp, like the 'idealist' Henner or the conventionally flattering Carolus-Duran, purveyors of the typical 'rich man's art' which Renoir despised. One may wonder at the presence of this man of the people, comparatively unlettered, a Bohemian painter of Montmartre, among them. It would seem that he and Georges Charpentier had met casually at La Grenouillère. The purchase of one of Renoir's pictures at the sale of 1875 led more specifically to an invitation. It is not to be supposed that Renoir found any special attraction in the salon as such. He had a distrust of literature as a bad influence on painting and his views of authors were seldom appreciative. He liked to hear Mallarmé talk but had only a glimmering through him of the sensuous

power of words. Renoir was not an intellectual. The household of the Charpentiers, in effect, represented for him, not 'culture' but a series of commissions, important not only as leading to a period of comparative success but as marking a climax in his career.

Having painted Mme Charpentier's mother-in-law and her little daughter, Georgette, he produced that excellent portrait of Mme Charpentier herself from which indeed one sees how misleading words can be in visual description. She is spoken of as small and plump: but how little this conveys the handsome presence in the Louvre portrait (Plate 27), the superb textures and that sheer pleasure in the presence of a woman which it was Renoir's peculiar genius to express. The crown of the series was the large 'conversation piece' (in the Metropolitan Museum) of Mme Charpentier and her daughters; that handsome composition which takes us into the home of the 'haute bourgeoisie'. A faint tinge of doubt may obtrude itself into one's admiration. There is perhaps a strain of formality in the arrangement of the family group. The artist, as well as the sitters, is on best behaviour. There is a suggestion of 'prettiness' in detail as distinct from his sense of charm: yet it is a work of consummate skill. It is, however, in the portrait of the friend of Mme Charpentier, encountered in her salon, the actress Jeanne Samary (whom he painted several times) that he attains a greater height. His delight in her beauty-'what a skin', he said, 'she positively lit up her surroundings'-is manifest. All the resources of his technique were lavished on the warm and glowing colour. Both the half- and full-length portraits, so alive and spontaneous, are masterpieces of their kind.

The favour of Mme Charpentier was undoubtedly a help to Renoir. She knew several members of the Salon jury and, whether this had influence or no, she was in any case a celebrity-the picture of herself and family was very well placed in the Salon of 1879. There was a surge of interest in his art. Whatever the critics might say about his colour, it was evident that he could paint children in a way that brought out all the appeal of childhood; what a shy attraction had his Mlle Jeanne Durand-Ruel, how plump and rosy was his Mlle Georgette Charpentier. One could not fail to appreciate that he liked to make the best of his models, though not to flatter but rather because this was how he looked at people, with a whole-hearted pleasure, in which there was no concealed element of criticism. The collector Deudon, who bought the Dancer, recommended Renoir to his friends the Bérards, a family well known in the diplomatic and banking worlds, and the result was a further series of distinguished portraits.

It might seem that the developments of the later 1870s were urging Renoir into the career of society portrait-painter. He had received 1,000 francs for the Charpentier group, a moderate enough sum but large from an Impressionist's point of view. One commission was leading to more. The situation had its dangers; society portraiture could lure an artist into facile mannerisms, prevent his free expression; but these threats were soon to be left behind in a process of personal development, still a long way from its end.

It was after the Salon of 1879 that Renoir began for the first time to travel. He was thirty-eight. Economic pressure was relaxing. His time had been spent, so far, almost entirely in Paris and the valley of the Seine and he wished to see something of the-world. His health was not very good and for a long period he had worked extremely hard and without pause. These were reasons for taking a holiday: but in several ways as he approached the age of forty he seemed to feel he was entering a new phase of life, calling for a pause, break or readjustment. It was not too soon to think of getting married-in 1881 he was married to young Mlle Aline Clavigot, who had posed for him more than once. It was the right moment also to take stock of his work and to consider where the Impressionist ideas might eventually lead.

His first journey was to the Normandy coast, as the guest of the Bérards, whose château at Wargemont was near the sea. The sea was not really his element and he could not find the same satisfaction as Monet in cliffs and waves, though in his study of the *Cliffs at Pourville* (1879) he gives a spacious feeling of height and distance, governed however by the human scale in the foreground figure of a man.

In 1880 he stayed the summer at Croissy with old friends, the restaurant-keepers Fournaise, of whom he had formerly made two masterly portraits; but the need for more definite change, and, it may well be, the example of Delacroix, who had found a visit to Algiers so rewarding, caused him to go there in company with Lestringuez. It was, he wrote to Mme Charpentier, 'an admirable country', though he struck a rainy season and came back after a few weeks with no very pronounced impressions. A subsequent visit to Algiers accounts for some figure studies in which there is a fragrance reminiscent of Delacroix. At the same time, one notes how little the artist could accommodate himself to the exotic: the face, for example, of the Algerian Woman (1881-2) is a type, with wide-set eyes, small nose, and of full oval shape, that appears often enough in his work to be called his own. After his marriage in 1881 he went to Italy with his young and comely wife, to Florence, Venice, Rome and Naples. It is plain that he was happier at home in France. 'Do you wish to know what I have seen?' he asked in a letter to Mme Charpentier. 'Take a boat and go to the quai des Orfèvres, or opposite the Tuileries and there's Venice. For Veronese, go to the Louvre. . . .' It was, no doubt, the kind of humour that inexperienced travellers indulge in when writing home. He was in fact impressed by Carpaccio, 'one of the first who dared to paint people walking in the street'-a comment which makes one think of Renoir's Place Pigalle. He was delighted with St Mark's: but the Renaissance churches of Italy depressed him; so did the 'lace-work' of Milan Cathedral; in Rome he was cheered only by the frescoes of Raphael and in Naples by the discovery of the paintings of the ancient world.

Renoir's idea of a holiday was to continue painting and study in museums. The principal landmarks of his journeys are the figure study of his wife (the *Blonde Bather*) painted at Naples, and of Wagner, whose portrait he painted at Palermo in a twenty-five minutes' sitting, the brilliant oil-sketch (of which later he made a replica) making the great composer look (not to his dissatisfaction) like a Lutheran pastor.

The unease of this period seems due, if not to a discontent with his own work, to a feeling that he had gone as far as it was possible for him to go in the study of surface appearance in nature, and in that interchange of light and colour which had become the Impressionist method. The time he spent in the museums increased his dissatisfaction and brought to the fore all that was conservative in his temperament. He had experienced the thrill of discovery but he did not like the idea of a standard or 'official' technique of Impressionism; nor the idea of a continuous quest for something new. No revolutionary, he refused to take part in an exhibition of 'new' art with Gauguin and Guillaumin on the ground that it savoured of 'politics'.

Returning to the old masters, he was compelled to find serious flaws in Impressionism. He reflected that those Greco-Roman artists of Pompeii were happy in having only ochres and browns on their palette (which was decidedly a heresy against the faith of Monet and Pissarro in the pure colours of the spectrum). Black, so often decried, was, as Tintoretto had observed, the 'Queen of Colours' and he knew from his own practice ho \vee deft touches of black added to the general brilliance of a colour scheme. There was a dubious theory, held by some critics, that Watteau had foreseen the method of Monet in 'the division of tonalities by touches of colour juxtaposed, reconstituting, at a distance from the eye, the true appearance of the object'. Renoir answered that *Embarking for Cythera* would reveal only mixed tones even if you took a magnifying

glass. He had, moreover, serious doubts about painting in the open air: you could not compose, nor could you see exactly what you were doing. Therefore you went back to the studio and in the studio you pursued precisely the same handicraft as the painters of the past with rules that did not change. His discovery in 1883 of Cennino Cennini's *Treatise on Painting* (for which in 1911 he wrote a preface) confirmed him in the belief that a fourteenth-century fresco painter had as much of value to impart as any modern. Perhaps, also, his stay at L'Estaque, about this time, with Cézanne, for whom he had a great admiration as a truly independent spirit among the Impressionists, confirmed him in the need, so much stressed by Cézanne, of referring constantly to the 'musée', of building upon the classic tradition.

For Renoir, this meant the Latin tradition: Velàzquez and Goya; the Venetians, Titian, Veronese; the great painters of France. Dutifully (but not warmly) admitting the greatness of Rembrandt, and allowing a wonderful exception in Vermeer, he thought Dutch and Flemish painting tedious and allowed no merit whatever to the English school.

The Boatmen's Lunch of 1881 (Plate 33) may be said to mark the end of a period in his art. In this representation of the open-air scene he knew so well, he showed all the skill so wonderfully displayed in the Moulin de la Galette. The delightful glimpse of landscape, the sparkling still-life on the festive table, the varied poses of the boaters, the haunting sense of the old 'fête champêtre', again arouse admiration. It would be hypercritical to advance as an objection that it does not add a fresh pleasure to that we have previously enjoyed: yet Renoir felt he was in danger of becoming static. He began to discard richness of incident and open-air effect in favour of simpler and well-defined form. A new precision of outline appears in the Blonde Bather of 1881. There is a tendency towards it in the series of paintings of dancing couples, of which the Dance at Bougival (Plate 35; 1883) is an example. A new insistence on formal or decorative elements of design, together with an enamel-like smoothness of surface that recalls the technique of Boucher (a little, also, that of the porcelain workshop) shows itself in The Umbrellas (1884). There is a great difference from the earlier pictures of the Parisian scene such as Leaving the Conservatoire, where the design makes itself, so to speak; in The Umbrellas (which can now be seen in the National Gallery in London) the formal pattern is artificially imposed to unify the moving crowd. There is a certain loss of the old spontaneous feeling, of the pulse of real life; to offset this, a decorative gain.

What was the 'classicism' to which the uncertainties and discontents of 1881 to 1883 (or thereabouts) eventually led? The representation of the human figure: the beauty not of transient effect but of form in a durable sense that allied it with sculpture: the choice of such elements as were timeless - e.g., a grove (but not a garden, the plan of which assigned it to a place or period), a piece of drapery (but not a period dress). These were eighteenth-century canons, such as the English student finds in Sir Joshua Reynolds's Discourses. In following them, Renoir placed a distance between himself and the convinced Impressionist-a Monet or Sisley, to whom the figure was of minor importance, who painted a landscape that was certainly of the nineteenth century, who was so much less interested in the sculptural form than the effect of light. The classical canons had their triumph in the great work which occupied Renoir for several years, The Bathers (Plate 37). Little concerned now with 'contemporanéité', Renoir openly borrowed from a bas-relief at Versailles of bathers by the seventeenth-century sculptor, François Girardon. The result was a picture of great beauty but divorced from time and place, with some of the sculptural quality of relief, while the nymphs bathe in the shade of trees whose foliage is no longer tremulous with light but dry and hard like that of a follower of Giotto.

It was the beginning of what is known as his 'manière aigre', his 'dry' period, though

Renoir was too much of an 'irregularist'-to borrow the word he invented for a possible society of artists-to be entirely consistent or uniform.

On the other hand, he is aware of the intimate aspect of life afforded by marriage. In 1886 his first son Pierre was born. In his new linear manner and yet with appreciation of the buxom appearance of Mme Renoir, with her baby at her breast, he painted the beautiful *Mother and Child* of 1886. Charm returns, here and in the *Washerwoman* and Child of 1886. It was not always easy to disengage real life from his classic aims, or alternatively to combine them with entire success. One is conscious of the effort in the somewhat metallic effect of the 'Au Piano' (Plate 40), as compared, let us say, with the Daughters of Cahen d'Anvers, of eight years before.

One sees Renoir in middle age, settling down in his home circle and in French country retreats, painting with an exclusive and unremitting industry. He rounded off his knowledge of the world outside France with a visit to Spain where he found no pretty women and a 'total absence of vegetation', being consoled only by Velàzquez (all the art of painting, he said, was in the pink ribbon worn by the Infanta Margarita); and Goya-his *Royal Family* alone was worth a visit to Madrid. He went to Holland, with no great excitement: and his short visits to England provoked only those disparaging reflections on Turner and an enthusiastic comment on the National Gallery's Claude Lorraines. In 1892 he went to Pont-Aven in Brittany, where he conceived great contempt for the 'international school of painting' as represented by Gauguin, his friend Emile Bernard and their entourage: not to speak of the seaside air which he blamed for increasing twinges of rheumatism.

In 1898 he bought a house at Essoyes in Burgundy, where he spent the summers with his family, but the creeping advance of arthritis caused him to seek the warm climate of the south at Cagnes, where he regularly spent the winter from 1903 onwards.

The settled domestic life had its influence on his art, at least as far as the choice of subject was concerned. Mme Renoir was constantly before his eyes to remind him with her own splendid proportions that a woman should be painted 'like a beautiful fruit'. His second son Jean was born in 1893, his third son Claude, nicknamed 'Coco', in 1901. They inspired more of those paintings of childhood in which he had always excelled: though his study of the little human group of which he was the head was more intimate than the commissioned portraits of earlier days, with an observation of everyday attitude and expression that is beautifully seen in the *Reading Lesson* and the *Writing Lesson*. The family progress through the years is commemorated in the *Mother* and Child of 1886; the picture of Jean Renoir and the servant Gabrielle (who so often served him as model – see Plate 47) and her little girl, in the early 1890s; the Artist's Family of 1896, with its, perhaps deliberate, emulation of the opulent manner of Rubens; Pierre, growing up, in 1898; Jean Renoir, in the white pierrot dress of Watteau's Gilles, in 1906; Mme Renoir, mature and benevolent-looking, in 1910.

The picture dealer, Ambroise Vollard, whom Renoir first met in 1894 (and painted several times-see Plate 46), and who subsequently became a familiar of the household, has given a pleasant evocation of its life which ran with unobtrusive smoothness. There was an air of prosperity. Since 1886 when the Impressionist Exhibition in New York took America by storm and created a constant demand for Impressionist pictures, Renoir like his confrères and their loyal supporter Durand-Ruel had been well out of the financial wood. Mme Renoir arranged things. She did not complain when the two servants Gabrielle and La Boulangère were requisitioned for a study of bathers. Under her supervision the bouillabaisse tasted better than elsewhere, though Renoir himself demanded of the cook only that her skin should 'take the light well'. She arranged, without his knowing how carefully, those vases of flowers which, to her delight, he sometimes painted. She thought of all the details at once: looking after the children, shelling peas, going to Mass, cleaning her husband's brushes-'he finds', she said, 'I clean them better than Gabrielle.'

Insensibly, one century gave way to another; in due course, and inevitably with a grumble at mechanical progress, Renoir had his automobile, though in a way his existence had become timeless. The intimate idyll was contained within a larger one, that of Provence itself. Provence where he was finally settled was the Hellas of France, the setting of a golden age. The olive trees on the estate of 'Les Collettes', his house at Cagnes from 1903 onwards, were reputed to be a thousand years old. In this landscape, with its blue and purple mountains in the distance, its grey olives, its slight vibration in the air that told of the nearness of the land-locked sea, its pervading warmth of colour, the nude figure could be placed in its proper context, its own country.

In his method of painting he came back to that transparency from which he had first been diverted by Courbet: a method approaching that of watercolour, a medium which, like Cézanne, he used occasionally with exceptional understanding. During his Impressionist days he applied transparent colour to reinforce the opaque substance of oil paint, in accents and surface touches-but from about 1890, he evolved his picture from transparent glazes through which the white canvas still appears.

It was in 1894, when he was fifty-three, that Renoir first endured those severe attacks of arthritis which made the later years of his life a physical martyrdom. He tried various cures, courses of massage and baths, saw, as he told Julie Manet, a lot of people come limping to Bourbonne-les-Bains and go away cured, but came to the conclusion that his own case was hopeless. 'Je suis pincé, ça va lentement mais sûrement.' He had operations on his knee, foot and hand. For several years he was able to get about with crutches, but at last in 1910 he was confined to a wheeled chair. In 1912 he was for a time completely paralysed. 'My husband', wrote Mme Renoir to Durand-Ruel from Cagnes, 'is beginning to move his arms though his legs are still the same. He can't stand upright, though he's getting used to being immobile. It is heartbreaking to see him in this state.' Wistfully she looked back to those happy days of 1881 at Naples.

Yet the man, helpless in his old age, with poor twisted joints, his thin sparsely bearded face puckered with pain, still had his humour and his will to create. He could think of himself as a *veinard*, a lucky chap, because he was able to paint in his chair. Sometimes he would grow fretful, and speak of giving up. Then the next morning, a fresh young model would arrive from Nice and he was happy again. Before ten he was at his easel in the garden studio, looking over the previous day's work, noting with satisfaction the quality of warm light in a landscape, or on youthful limbs. 'It's a pity', he remarked, 'they won't be able to say I painted surrounded by nymphs and crowned with roses or with a pretty girl on my knees like the Raphael of Ingres.' The brush was affixed with sticking plaster to his crumpled hand – he called it 'putting on his thumb'. Once in position it was obviously not practicable to change brushes at intervals. He used the same brush throughout, dipping it in turpentine at intervals to clean it. The brush stroke was fumbling yet this did not weaken the power of the vision he transferred to canvas, which seemed even to gain, in youth and energy, as it grew more difficult for him to work.

In these years he made his experiments in sculpture. One is inclined to think of Renoir solely as painter and colourist, yet he could dispense with colour and had tried other media. While still able to use his hand freely, he made a few etched plates, the first a soft-ground etching for the *Pages* of Mallarmé, published in 1891. A more congenial experiment was lithography (see Plate 41), and about 1904 he made a number of lithographic prints in which he found himself well able, with the soft chalk, to 'model' a figure without the use of colour. This led on to his essay in actual modelling; his first effort in 1907 being the fine relief of *Coco* (the only sculpture executed by his own hand). Other medallions, the high-relief of the *Judgment of Paris* and the completely plastic *Venus Victrix* belong to the period of immobility. He could see, he could not model. One thinks of the opposite case of Degas, who called a sculpture a blind man's art, and with blurred vision relied, in producing his wonderful statuettes, on the sense of touch. Renoir, on the contrary, worked by remote control, directing the hands of two intelligent young craftsmen by means of a long stick, conjuring up, with this wand, a massive goddess, superbly and in no imitative fashion 'antique'.

The struggle of the crippled man is one of the heroic legends of art. Not only would he not give in, he contemplated fresh triumphs, was able to achieve them. Immersed in his efforts, transported into the timeless world of his bathers, one realizes with a shock of surprise that the clock of history had moved inexorably on and that war loomed – the First World War.

Renoir in 1914 was seventy-three, Pierre was twenty-nine, Jean twenty-one. The young men went into the army. The old people were left together. Renoir, who remembered well the false optimism of 1870, was sceptical of the flying rumours of quick victory. The 'Russian steam-roller', he was told, would crunch its way to Berlin by October. 'Now', said Renoir, 'I become really uneasy. They are going mad.' Thinking of his sons he flung down his brushes one day. 'I shall paint no more.' Mme Renoir knitting a soldier's scarf sighed and bent over her work.

Pierre and Jean were both wounded. Mme Renoir died in June, 1915. The lonely old artist went on painting and the final phase of these war years is something to marvel at. He pursued his evolution to the end in that final burst of free and entirely personal expression in which some of the greatest painters (Titian and Turner are examples) have found complete fulfilment.

From the wheeled chair he could paint a portrait as well as ever. There is great verve in the portrait of Mme Galéa painted at Nice in 1912, no less in the brilliant portrait of Vollard in 1917. Few men incidentally can have been portrayed by so many gifted hands in so many different ways. His appearance as a bullfighter is explained by Renoir's desire to paint the silver and blue costume of the matador. Vollard had it made specially in Spain.

Yet the peak of Renoir's achievement is to be found in his final interpretation of the nude, the last swirl of chromatic delight. He had found a new model, 'Dédé', whom one detects in the roseate bathers with their small firm breasts and long flanks. She has her importance in having incited him to the eager activity that culminates in *The Bathers* of 1918 (Plate 43) with its rosy flush of colour, its expression of form as distinct and masterly as Cézanne's though so different from it. We cease to think of the real world: we enter the world of Renoir's mind, the ultimate vision of timeless beauty.

He died in 1919, aged seventy-eight, after a bout of pneumonia that lasted for a fortnight, murmuring towards the end, 'I begin to show promise.' Of the Impressionists only his old friend Monet, who died in 1926, outlived him. Renoir had 'arrived' as not many painters had in their lifetime. Honours were showered upon him. His studio at Cagnes was a place of pilgrimage. In August 1919 the portrait of Mme Charpentier was among the acquisitions of the Louvre and he was wheeled in his chair through the galleries 'like a pope of painting'.

List of Plates

- 1. Mademoiselle Sicot. 1865. Canvas, 116 \times 89.5 cm. Washington, National Gallery of Art (Chester Dale Collection).
- 2. Spring Bouquet. 1866. Canvas, 104 × 80.5 cm. Cambridge, Massachusetts, Fogg Art Museum.
- 3. Diana. 1867. Canvas, 199.5 × 129.5 cm. Washington, National Gallery of Art (Chester Dale Collection).
- 4. Portrait of Lise. 1867. Canvas, 180 × 112.4 cm. Essen, Folkwang Museum.
- 5. 'La Baigneuse au Griffon.' 1870. Canvas, 184
 × 115 cm. São Paulo, Brazil, Museum of Modern Art.
- 6. La Grenouillère. 1869. Canvas, 66.25×81 cm. Stockholm, Nationalmuseum.
- 7. Path Winding through High Grass. About 1876. Canvas, 60 × 74 cm. Paris, Louvre (Jeu de Paume).
- 8. The Painter Bazille in his Studio. 1867. Canvas, 106 × 74 cm. Paris, Louvre (Jeu de Paume).
- Young Soldier. 1877. Canvas, 54 × 32 cm. Upperville, Virginia, Collection of Mr & Mrs Paul Mellon.
- 10. Odalisque. 1870. Canvas, 69.2×122.6 cm. Washington, National Gallery of Art (Chester Dale Collection).
- 11. 'La Nymphe à la Source.' About 1870–5. Canvas, 66.5×124 cm. London, National Gallery.
- 12. Claude Monet Reading. 1872. Canvas, 61 × 50 cm. Paris, Musée Marmottan.
- 13. Portrait of Madame Claude Monet. 1872. Canvas, 61 × 50 cm. Paris, Musée Marmottan.
- A Girl with a Watering Can. 1876. Canvas, 100.3 × 73.2 cm. Washington, National Gallery of Art (Chester Dale Collection).
- 15. The Dancer. 1874. Canvas, 142.5×94.5 cm. Washington, National Gallery of Art (Widener Collection).
- 16. 'La Loge.' 1874. Canvas, 80×64 cm. London, Courtauld Institute Galleries.
- 17. 'La Première Sortie.' 1876/7. Canvas, 65×51 cm. London, National Gallery.
- 18. Girl Reading a Book. 1875/6. Canvas, 47×38 cm. Paris, Louvre (Jeu de Paume).
- Portrait of Madame Henriot. About 1876. Canvas, 65.9 × 49.8 cm. Washington, National Gallery of Art (Adele R. Levy Fund, Inc.).
- 20. The Café. About 1876/7. Canvas, 35×28 cm. Otterlo, Kröller-Müller Museum.
- Scene in Renoir's Studio, Rue Saint-Georges. 1876. Canvas, 45 × 37 cm. Private Collection.
- 22. Qn the Seine, near Argenteuil. About 1876/7. Canvas, $47 \times 57^{\cdot 2}$ cm. Osaka, Japan, Private Collection.
- 23. Summer Landscape. 1873. Canvas, 54.5×65 cm. Private Collection.

- 24. Under the Arbour at the Moulin de la Galette ('La Tonnelle'). 1876. Canvas, 81 × 65 cm. Moscow, Pushkin Museum.
- 25. Female Nude. 1876. Canvas, 93×73 cm. Moscow, Pushkin Museum.
- 26. Portrait of Victor Chocquet. 1876. Canvas, 46 \times 36 cm. Winterthur, Oskar Reinhart Collection.
- 27. Portrait of Madame Charpentier. About 1877. Canvas, 46 × 38 cm. Paris, Louvre (Jeu de Paume).
- 28. At the Moulin de la Galette. 1876. Canvas, 131 × 175 cm. Paris, Louvre (Jeu de Paume).
- 29. The Skiff ('La Seine à Asnières'). About 1879. Canvas, 71 × 92 cm. London, National Gallery (on loan).
- 30. Detail of Plate 33.
- 31. Roses in a Vase. About 1876. Canvas, 60.7×51.4 cm. Private Collection.
- 32. Oarsmen at Chatou. 1879. Canvas, 81.3 × 100.3 cm. Washington, National Gallery of Art (Gift of Sam A. Lewisohn).
- 33. The Boatmen's Lunch. 1881. Canvas, 127.5 \times 175.5 cm. Washington, The Phillips Collection.
- 34. Jugglers at the Cirque Fernando (detail). 1879. Canvas, 131 × 99 cm. Chicago, Art Institute.
- 35. Dance at Bougival. 1883. Canvas, 179 × 98 cm. Boston, Museum of Fine Arts.
- 36. Fantasia, Algiers. 1881. Canvas, 73.5 × 92 cm. Paris, Louvre (Jeu de Paume).
- 37. The Bathers. 1884–7. Canvas, 115 × 170 cm. Philadelphia, Museum of Art (Mr & Mrs Carroll S. Tyson Collection).
- 38. Woman with a Fan (detail). 1880. Canvas, 65×50 cm. Leningrad, Hermitage.
- 39. 'Le Chapeau à Cerises.' 1884. Canvas, 55.9 \times 45.7 cm. Private Collection.
- 40. 'Au Piano.' 1892. Canvas, 116×90 cm. Paris, Louvre (Jeu de Paume).
- 41. 'Le Chapeau Épinglé.' 1897. Coloured lithograph, 60 × 48.8 cm. Ikeda, Japan, Museum of 20th Century Art.
- 42. Nude Figures in a Landscape. 1910. Canvas, 40×51 cm. Stockholm, Nationalmuseum.
- 43. The Bathers. About 1918. Canvas, 110 × 160 cm. Paris, Louvre (Jeu de Paume).
- 44. Roses in a Vase. About 1900. Canvas, 29.5 × 35 cm. Paris, Louvre (Jeu de Paume).
- 45. Portrait of a Young Woman in a Blue Hat. About 1900. Canvas, 47×55.9 cm. Private Collection.
- 46. Portrait of Ambroise Vollard. 1908. Canvas, 81×64 cm. London, Courtauld Institute Galleries.
- 47. Gabrielle with a Rose. 1911. Canvas, 55 × 46 cm. Paris, Louvre (Jeu de Paume).
- 48. Dancing Girl with Castanets. 1909. Canvas, 155×64.8 cm. London, National Gallery.

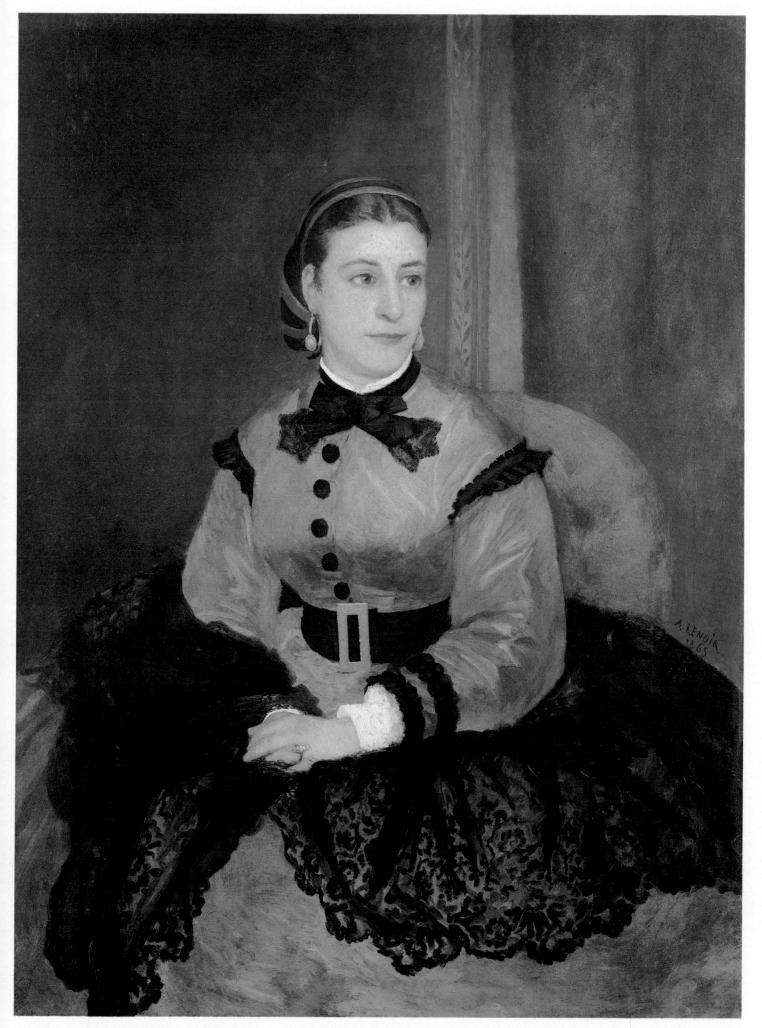

1. Mademoiselle Sicot. 1865. Washington, National Gallery of Art (Chester Dale Collection)

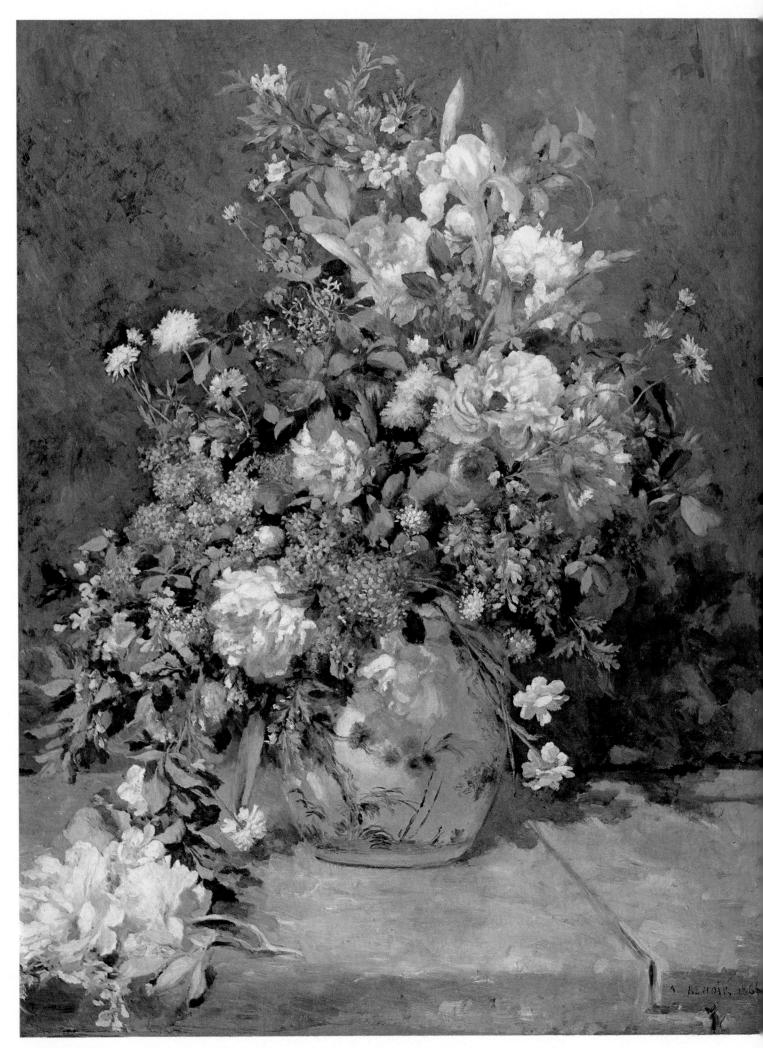

2. Spring Bouquet. 1866. Cambridge, Massachusetts, Fogg Art Museum

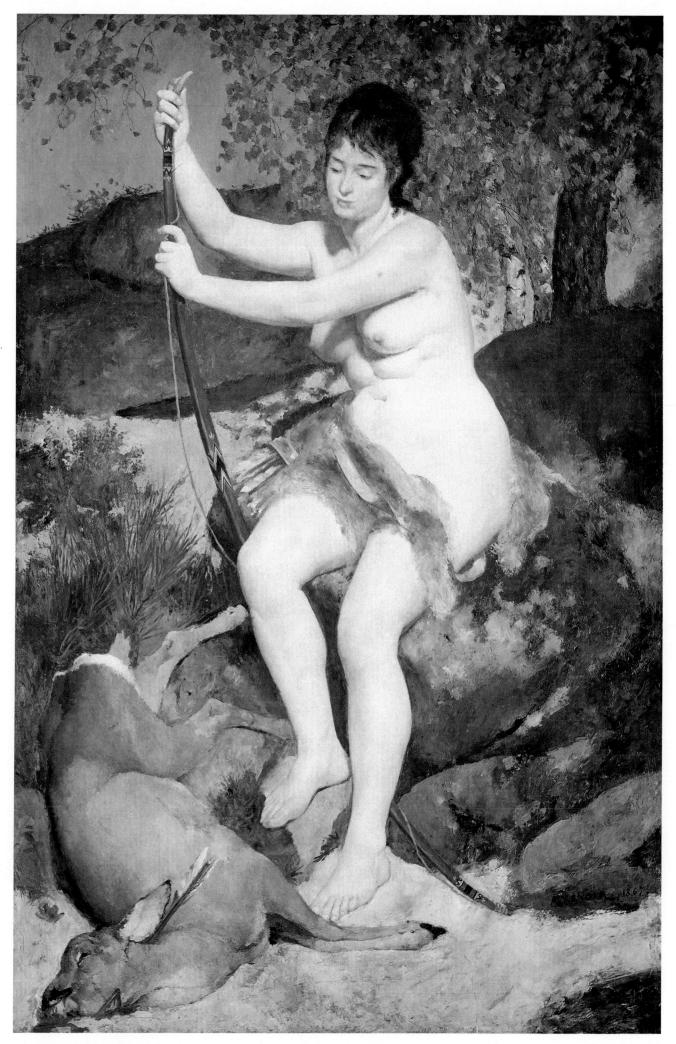

3. Diana. 1867. Washington, National Gallery of Art (Chester Dale Collection)

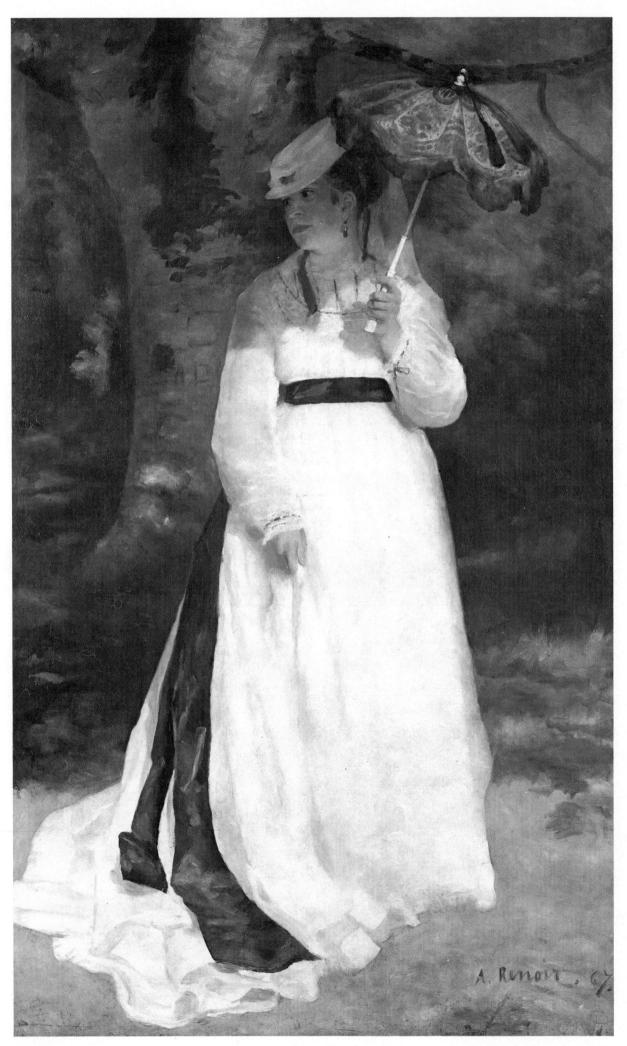

4. Portrait of Lise. 1867. Essen, Folkwang Museum

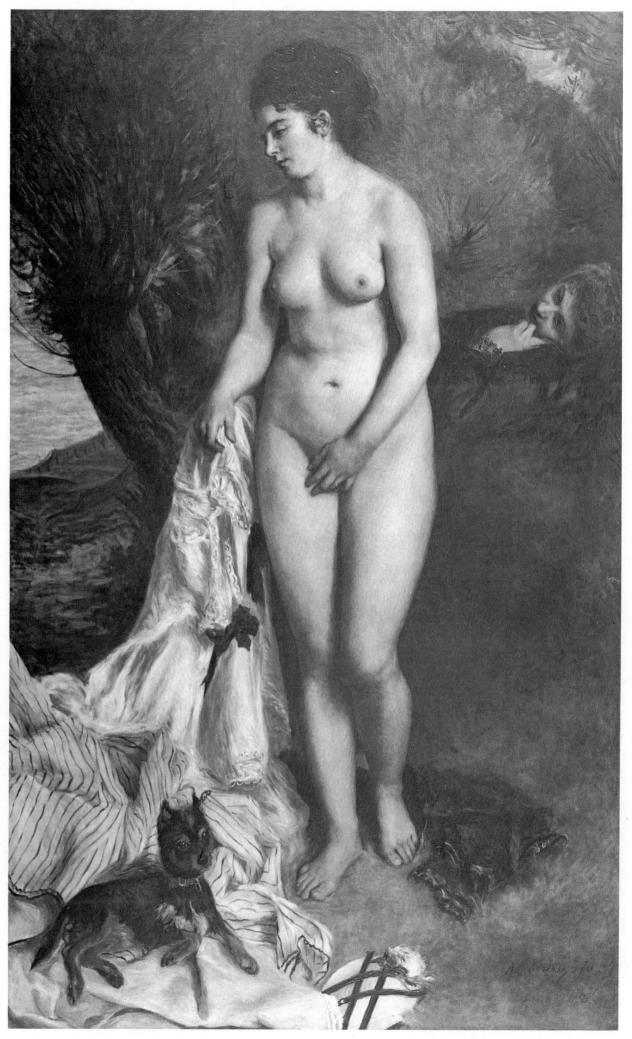

5. 'La Baigneuse au Griffon.' 1870. São Paulo, Brazil, Museum of Modern Art

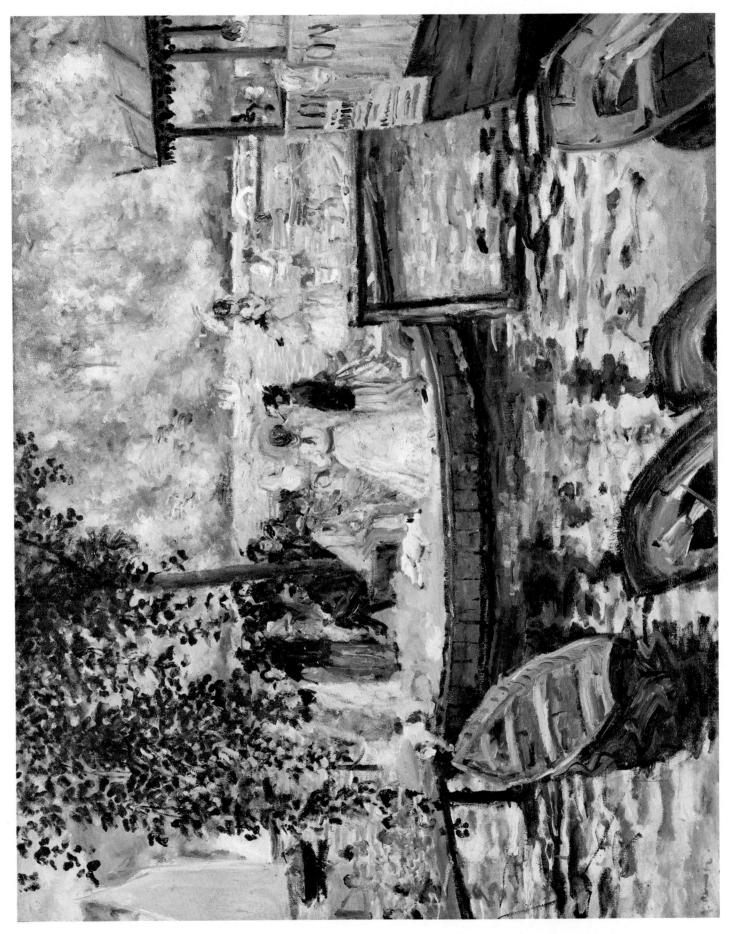

6. La Grenouillère. 1869. Stockholm, Nationalmuseum

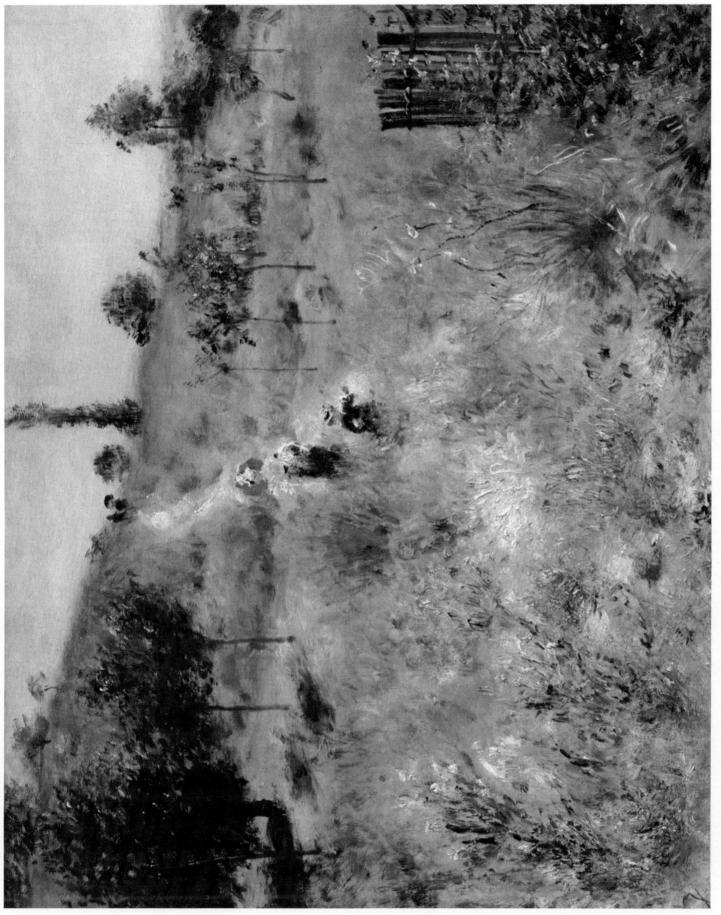

7. Path Winding through High Grass. About 1876. Paris, Louvre (Jeu de Paume)

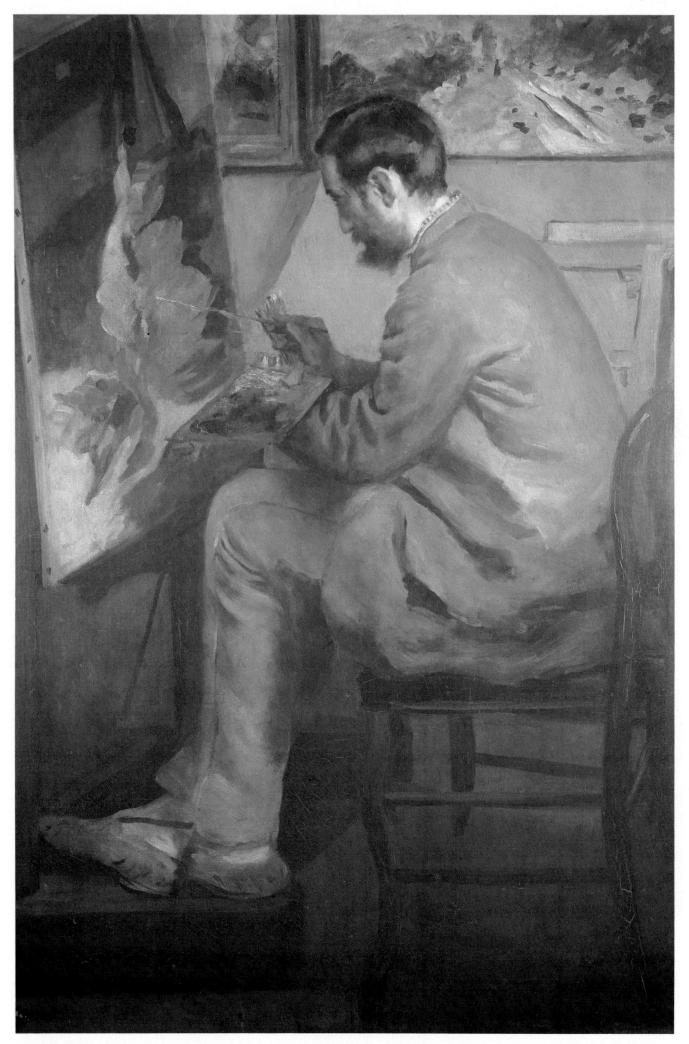

8. The Painter Bazille in his Studio. 1867. Paris, Louvre (Jeu de Paume)

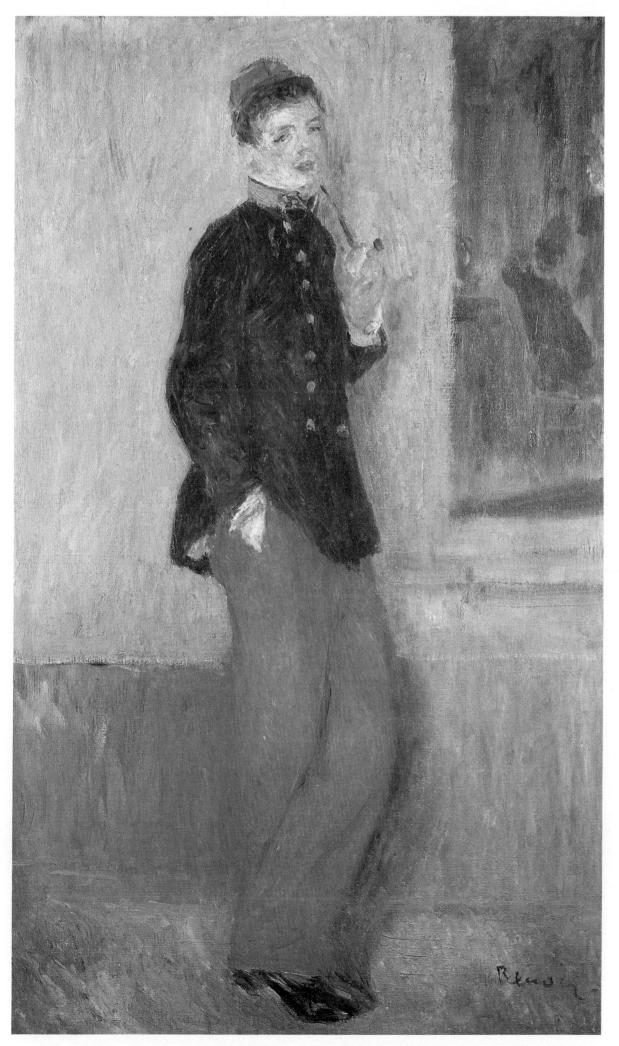

9. Young Soldier. 1877. Upperville, Virginia, Collection of Mr & Mrs Paul Mellon

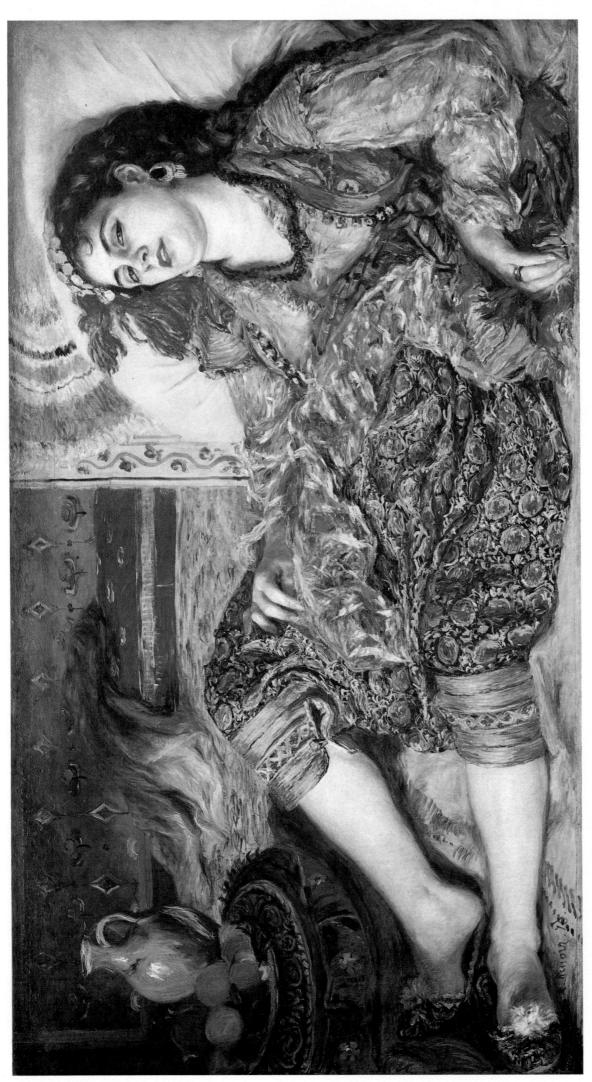

10. Odalisque. 1870. Washington, National Gallery of Art (Chester Dale Collection)

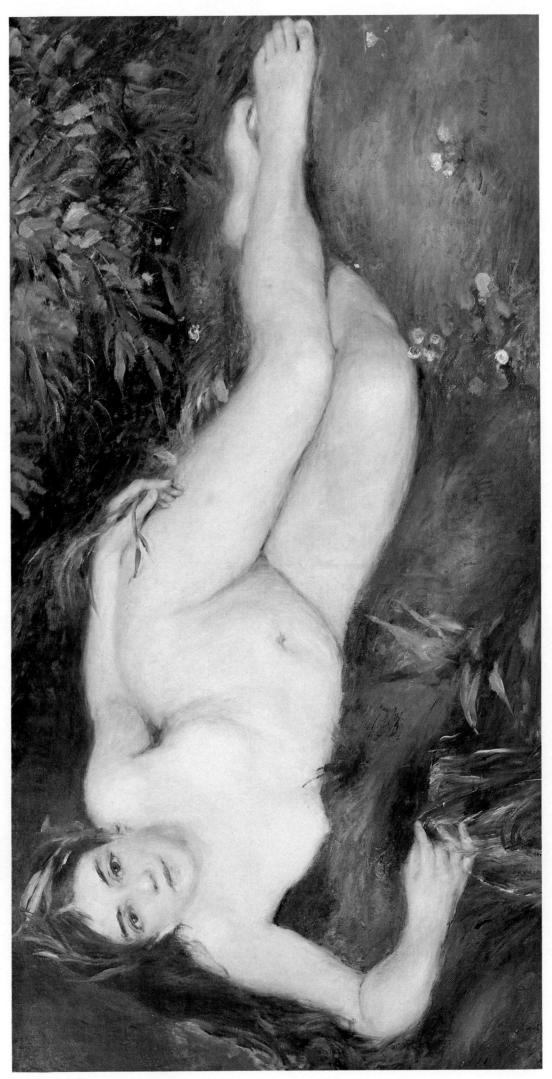

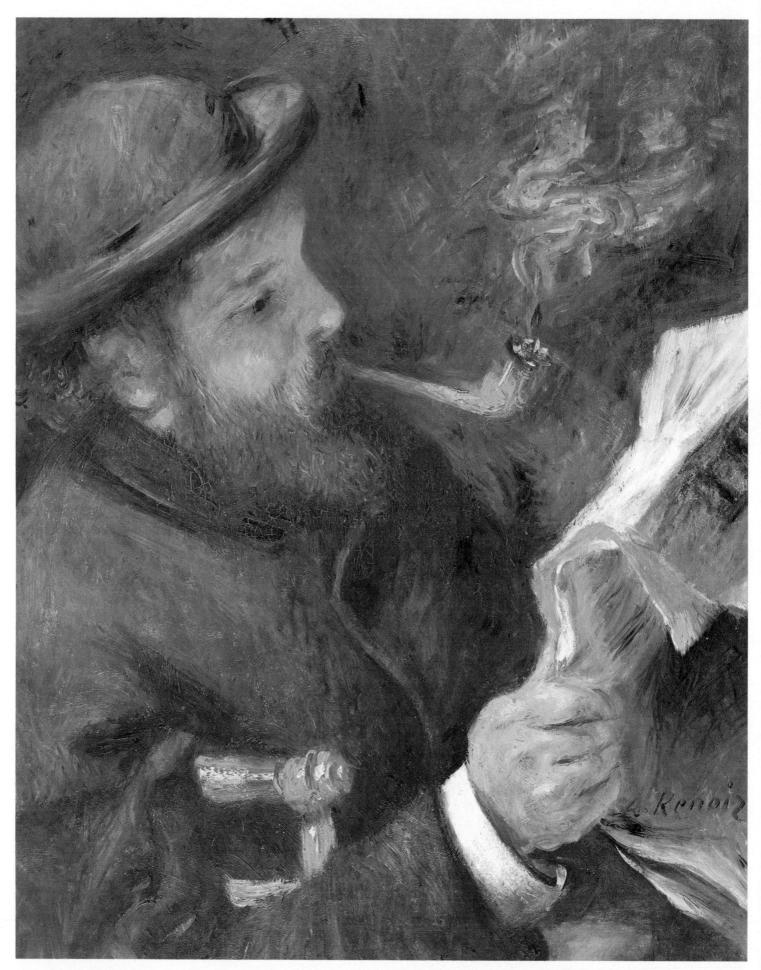

12. Claude Monet Reading. 1872. Paris, Musée Marmottan

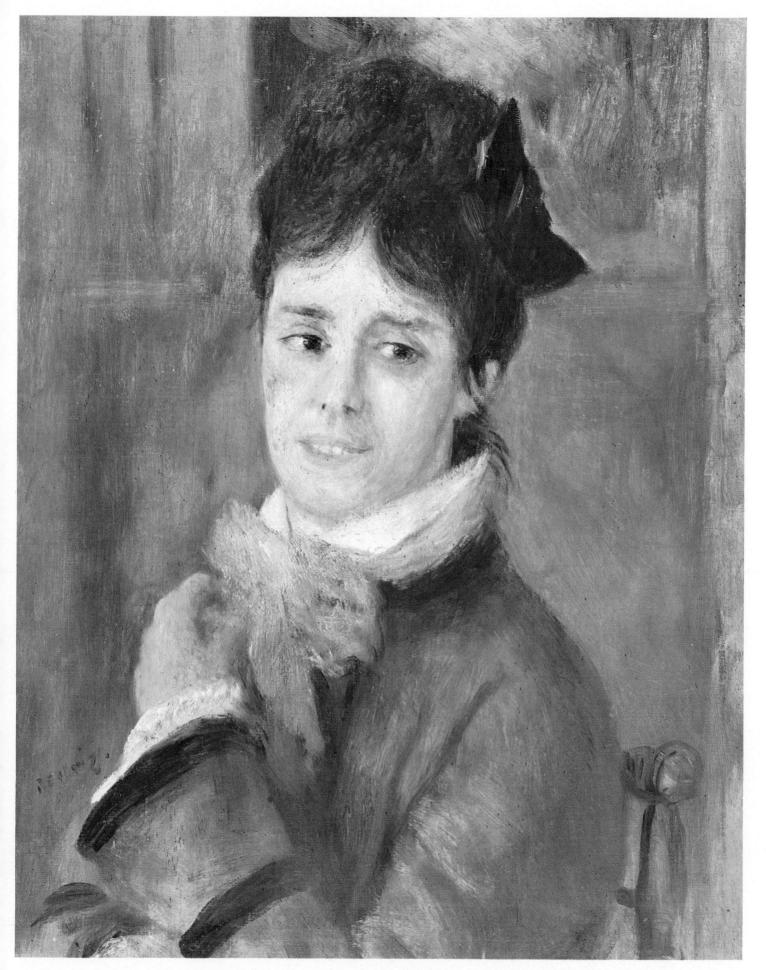

13. Portrait of Madame Claude Monet. 1872. Paris, Musée Marmottan

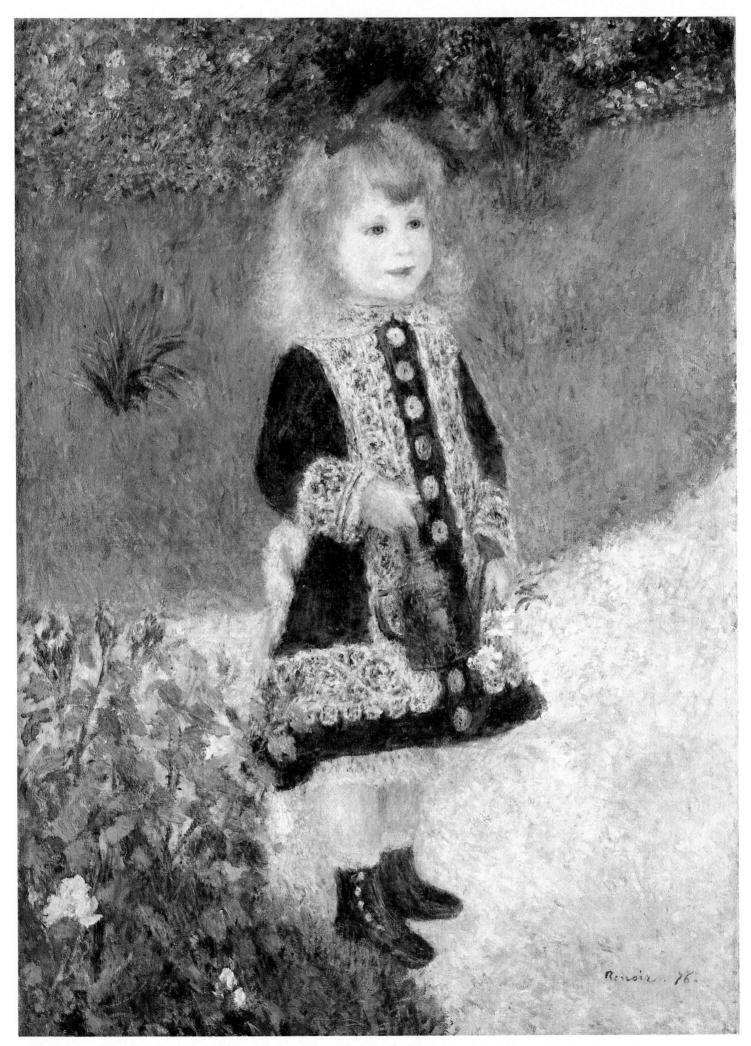

14. A Girl with a Watering Can. 1876. Washington, National Gallery of Art (Chester Dale Collection)

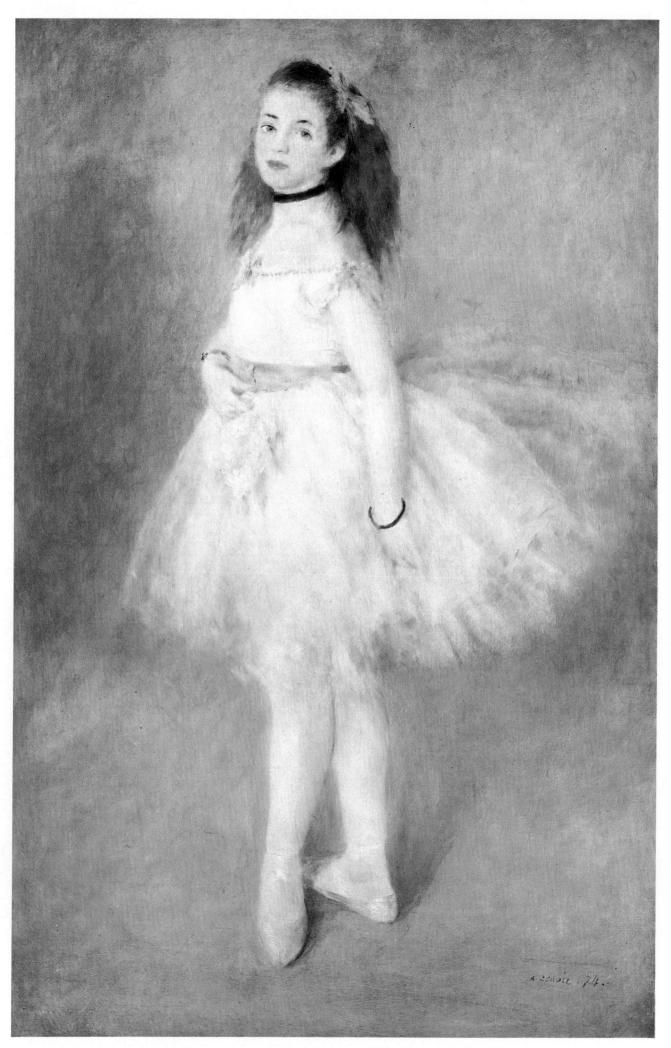

15. The Dancer. 1874. Washington, National Gallery of Art (Widener Collection)

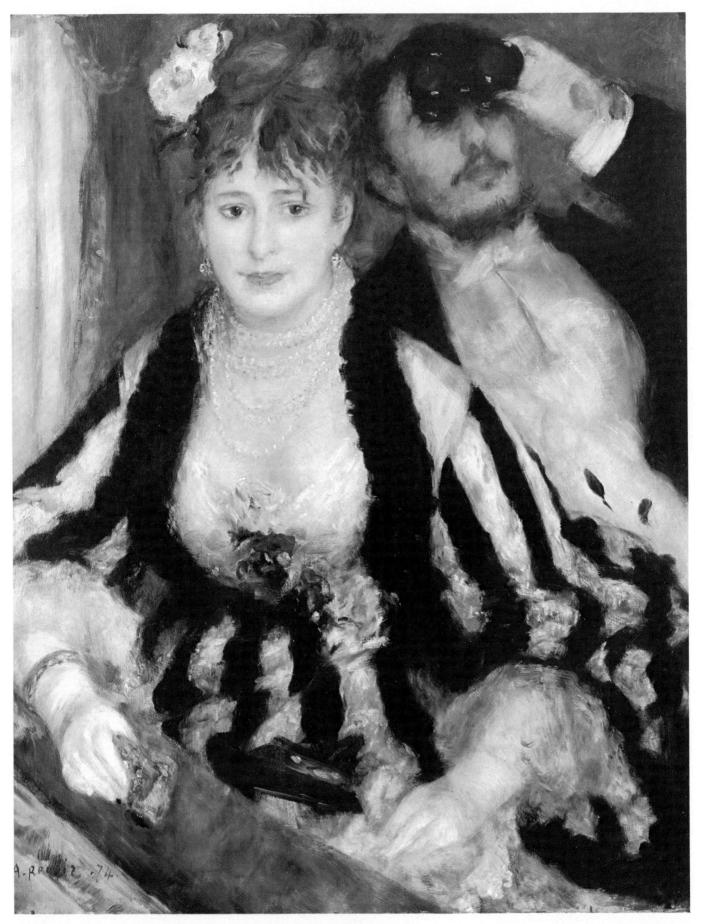

16. 'La Loge.' 1874. London, Courtauld Institute Galleries

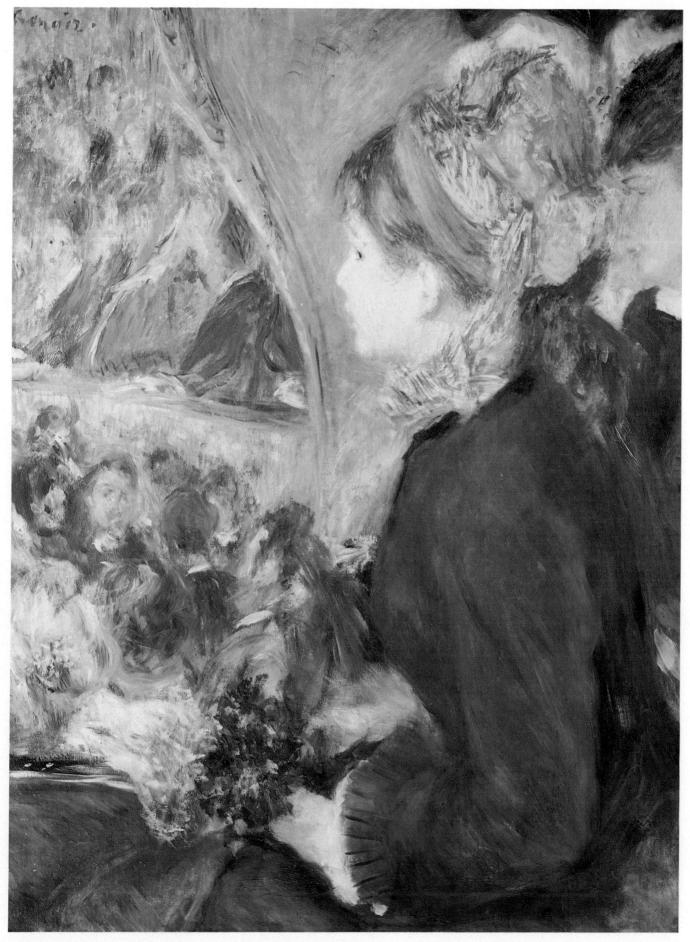

17. 'La Première Sortie.' 1876/7. London, National Gallery

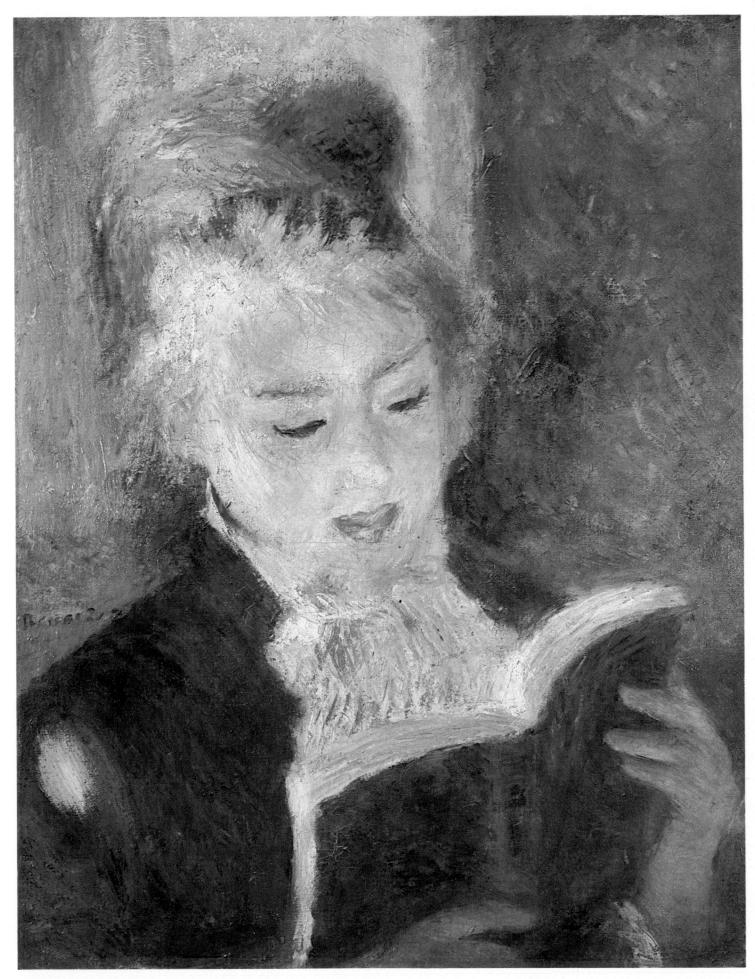

18. Girl Reading a Book. 1875/6. Paris, Louvre (Jeu de Paume)

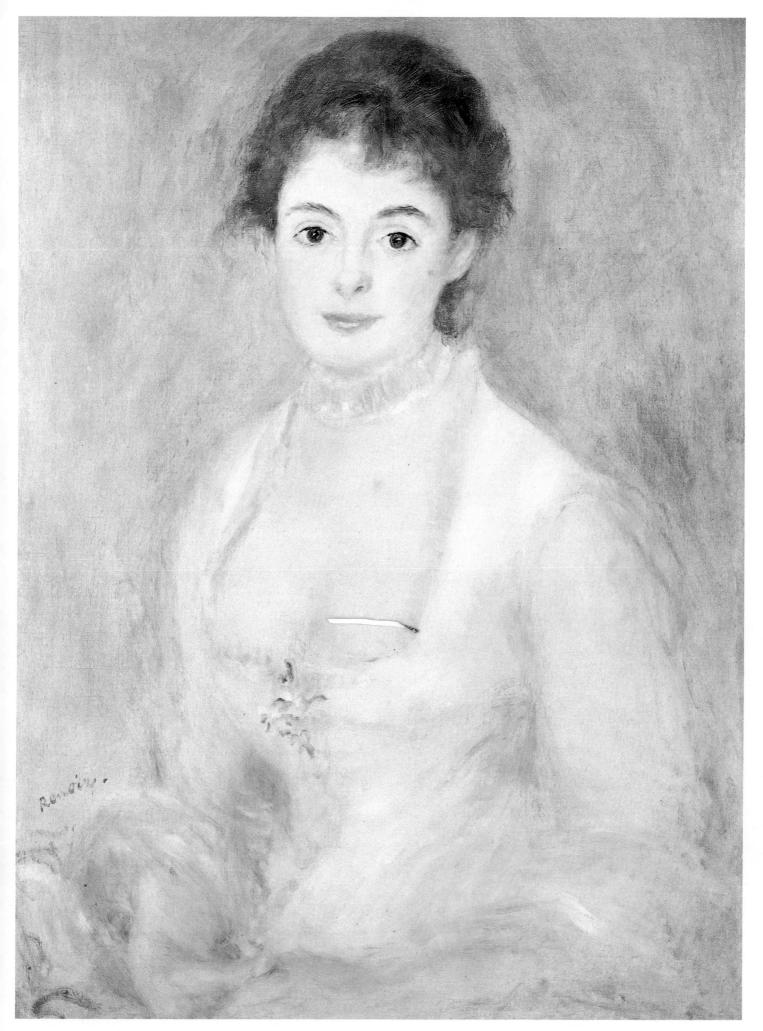

19. Portrait of Madame Henriot. About 1876. Washington, National Gallery of Art (Adele R. Levy Fund, Inc.)

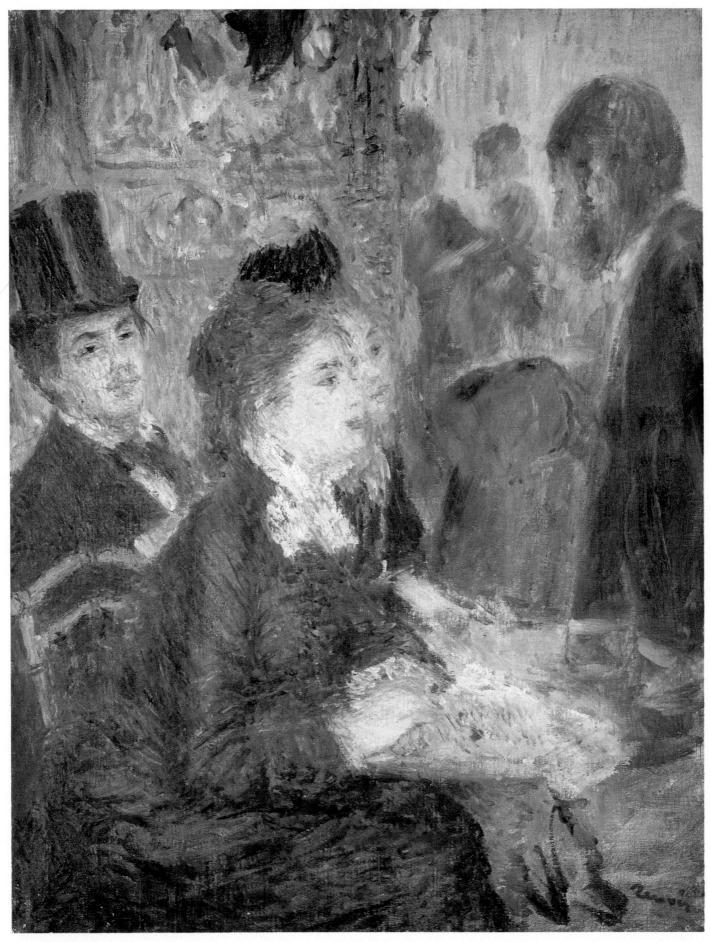

20. The Café. About 1876/7. Otterlo, Kröller-Müller Museum

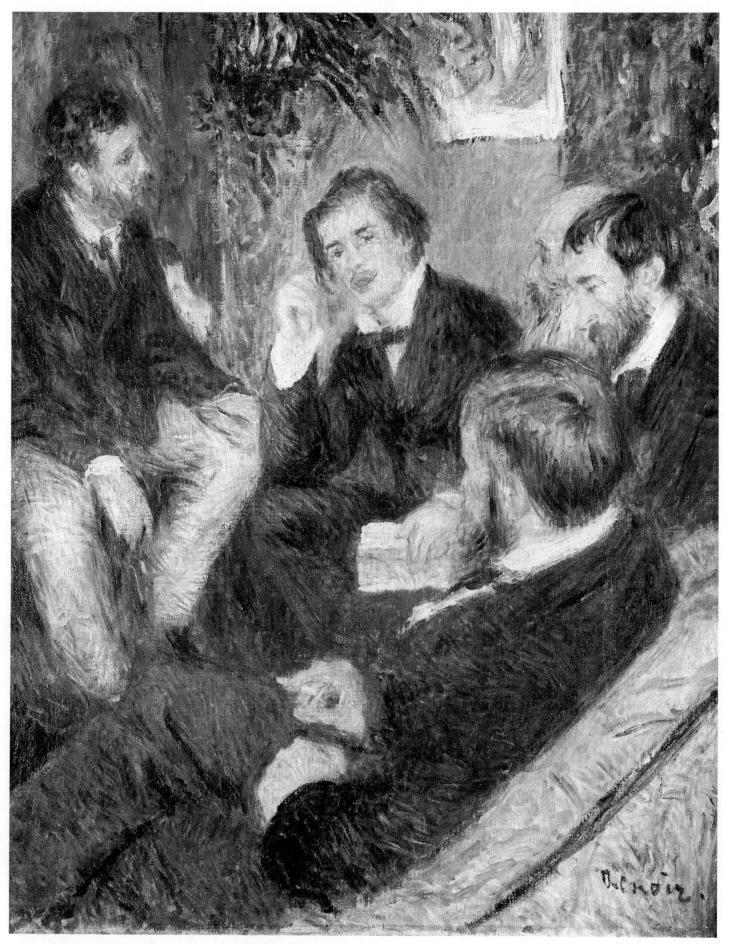

21. Scene in Renoir's Studio, Rue Saint-Georges. 1876. Private Collection

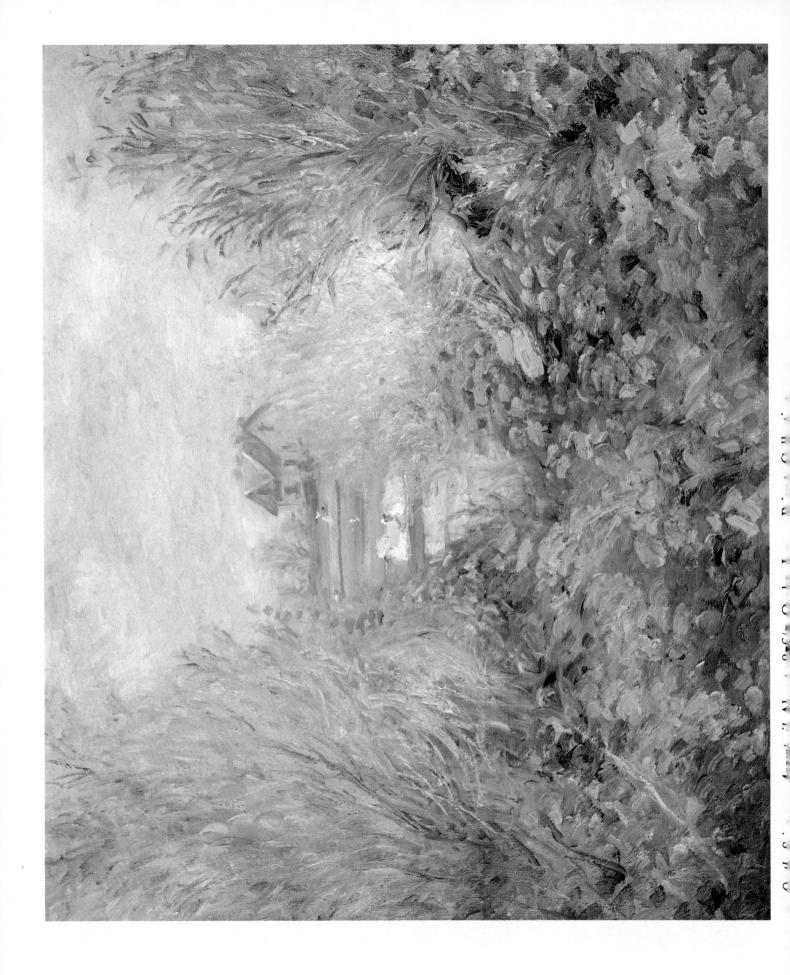

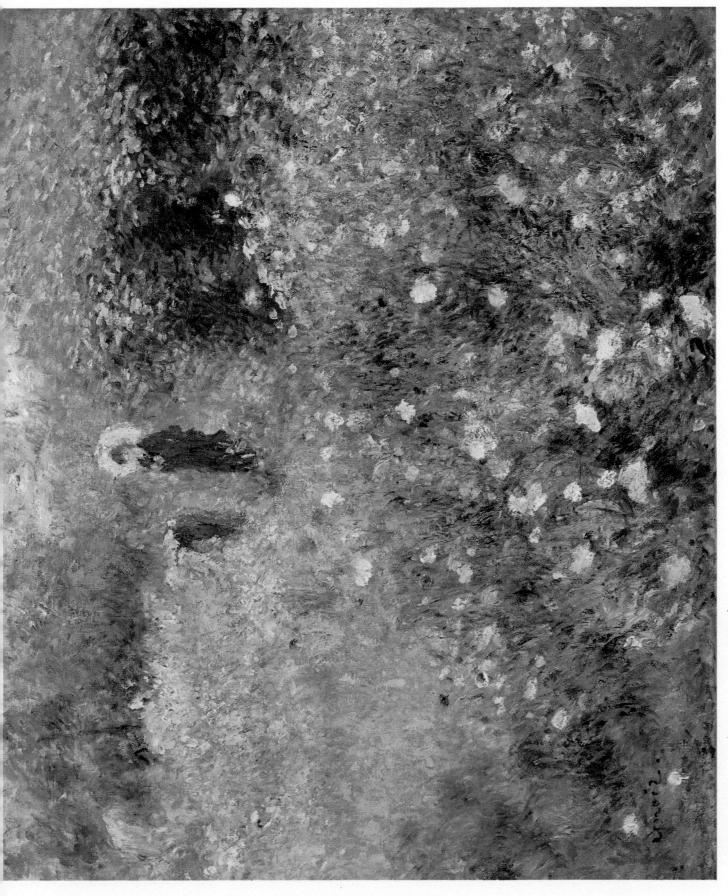

23. Summer Landscape. 1873. Private Collection

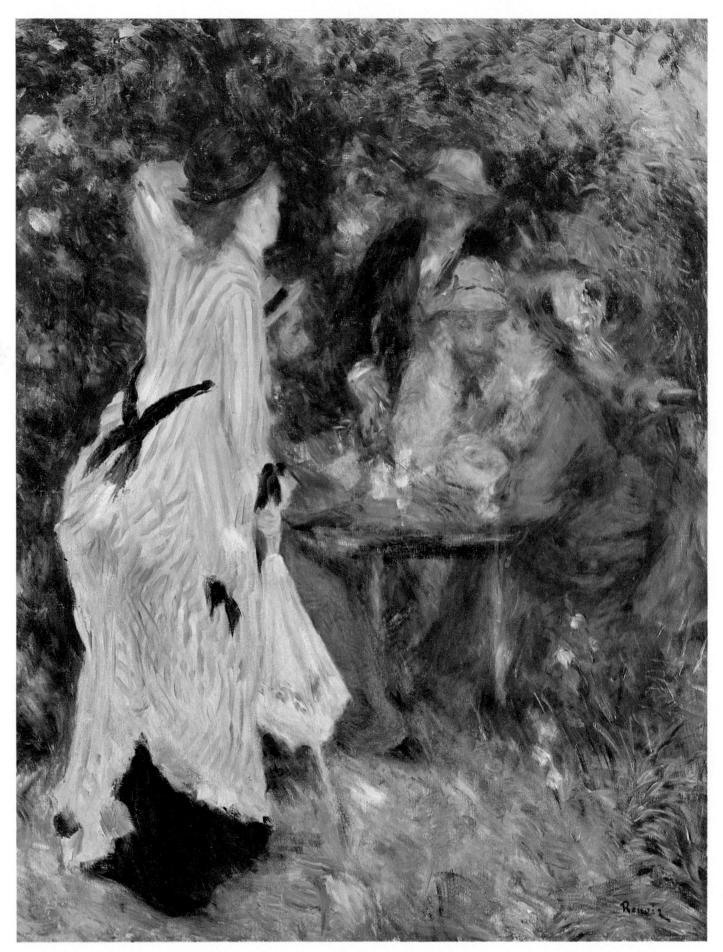

24. Under the Arbour at the Moulin de la Galette ('La Tonnelle'). 1876. Moscow, Pushkin Museum

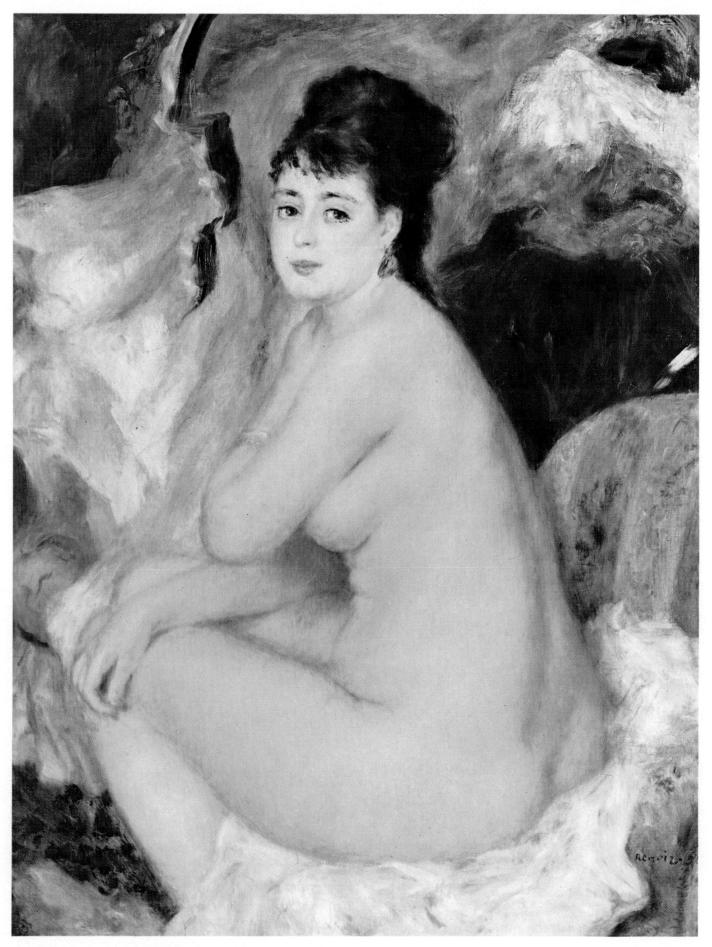

25. Female Nude. 1876. Moscow, Pushkin Museum

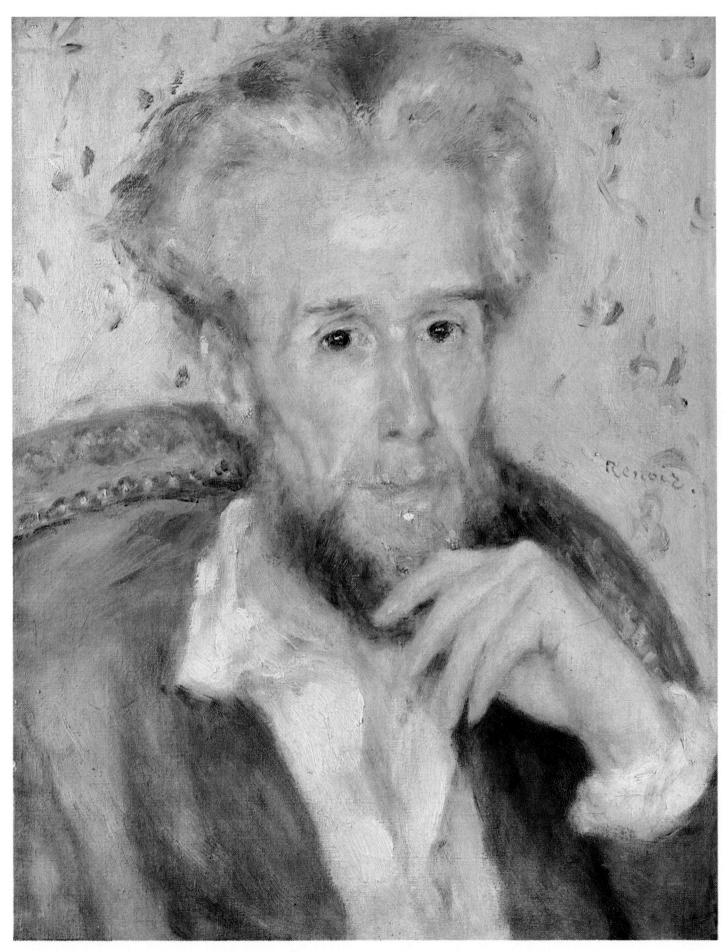

26. Portrait of Victor Chocquet. 1876. Winterthur, Oskar Reinhart Collection

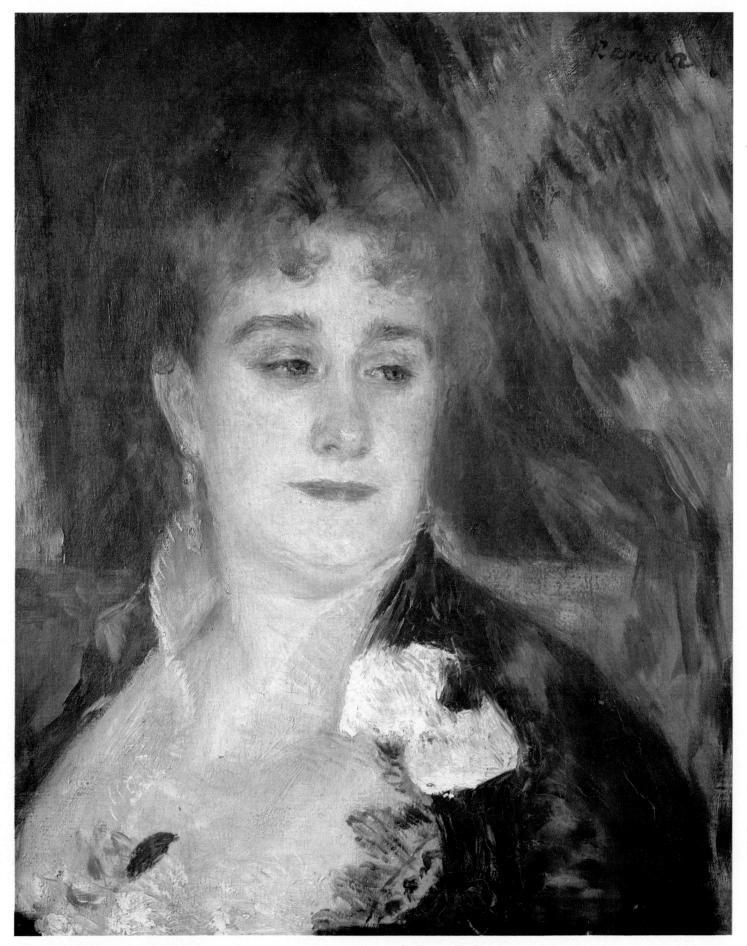

27. Portrait of Madame Charpentier. About 1877. Paris, Louvre (Jeu de Paume)

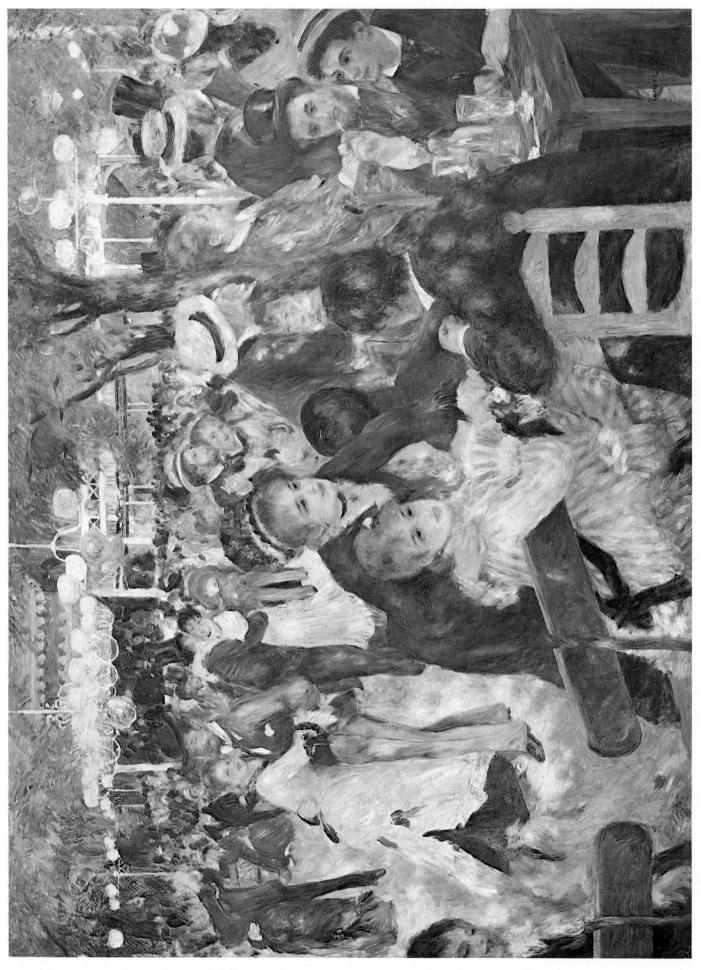

28. At the Moulin de la Galette. 1876. Paris, Louvre (Jeu de Paume)

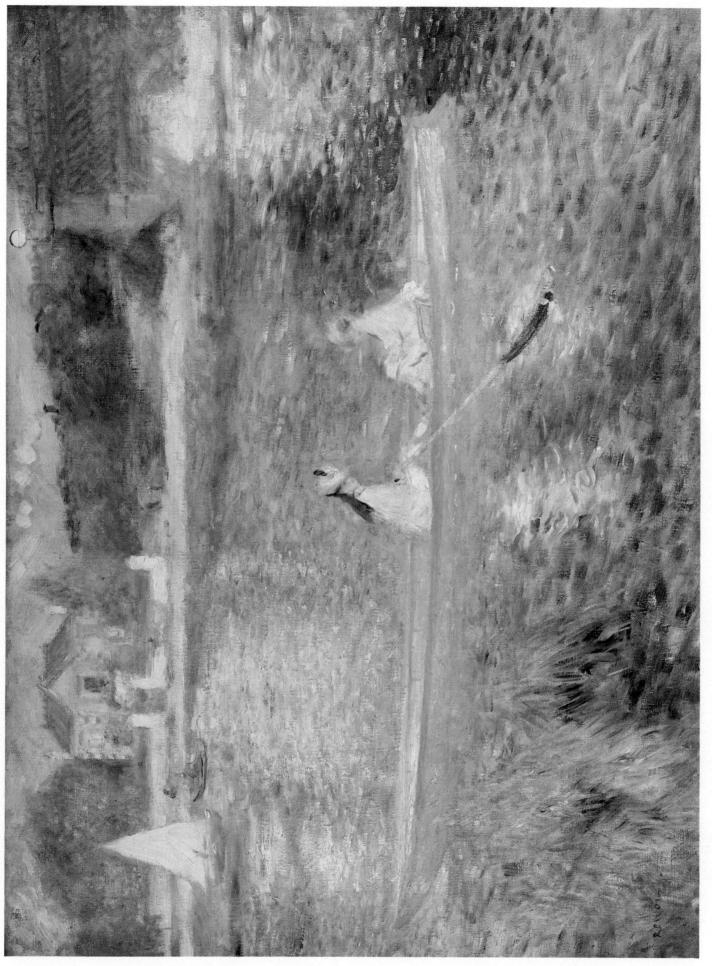

29. The Skiff ('La Seine à Asnières'). About 1879. London, National Gallery (on loan)

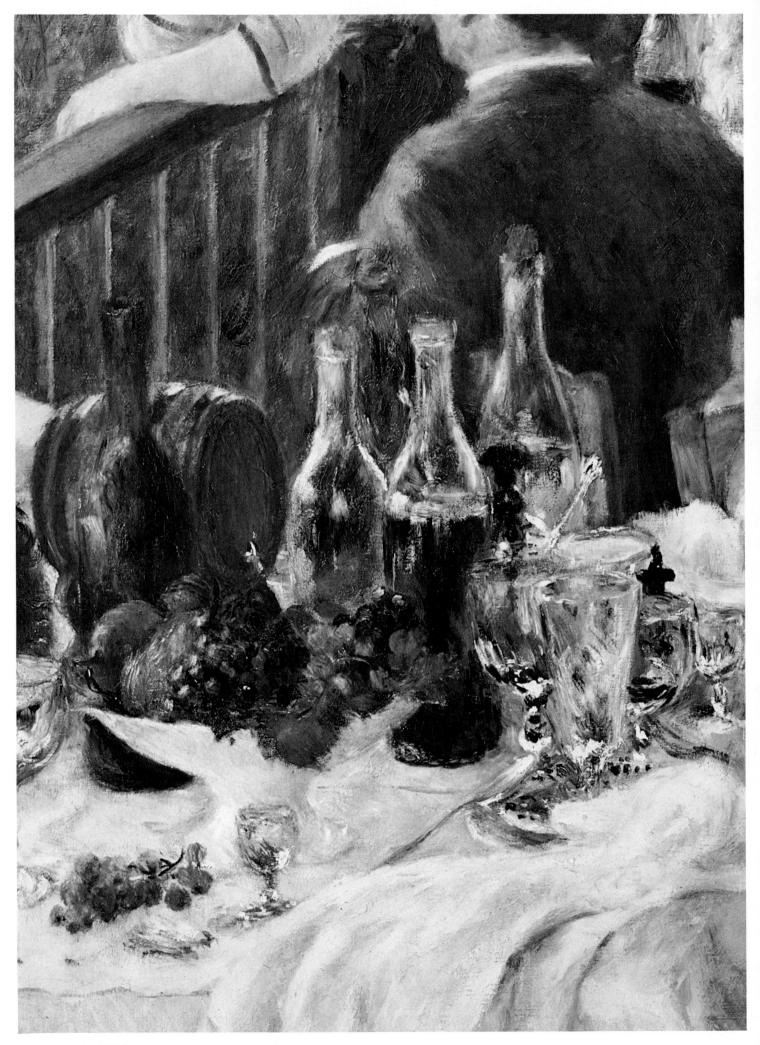

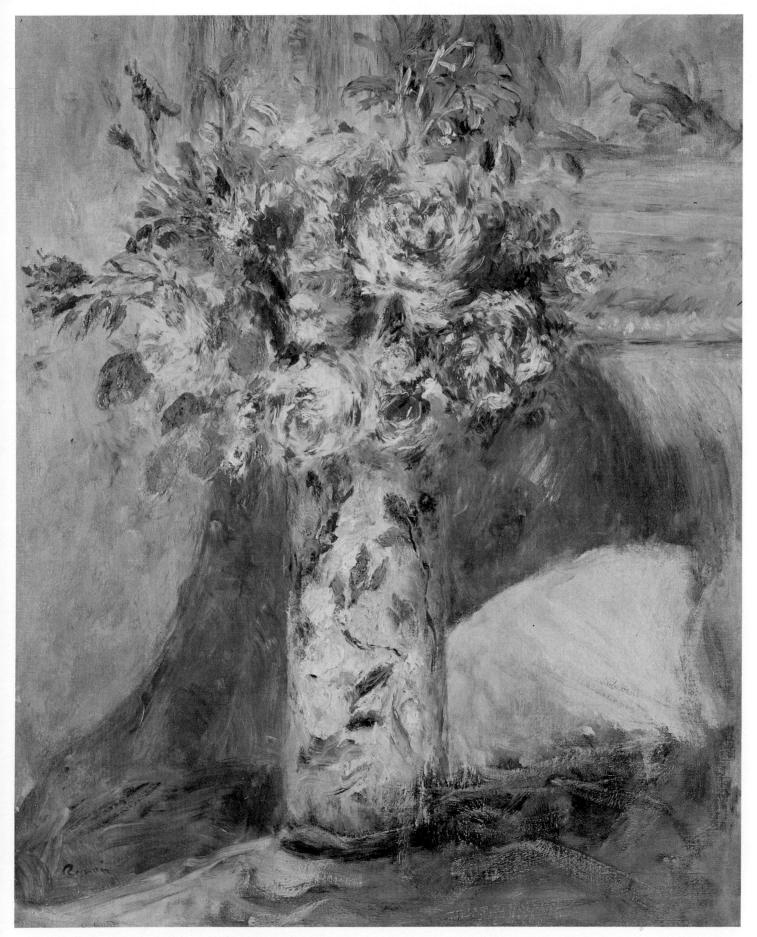

31. Roses in a Vase. About 1876. Private Collection

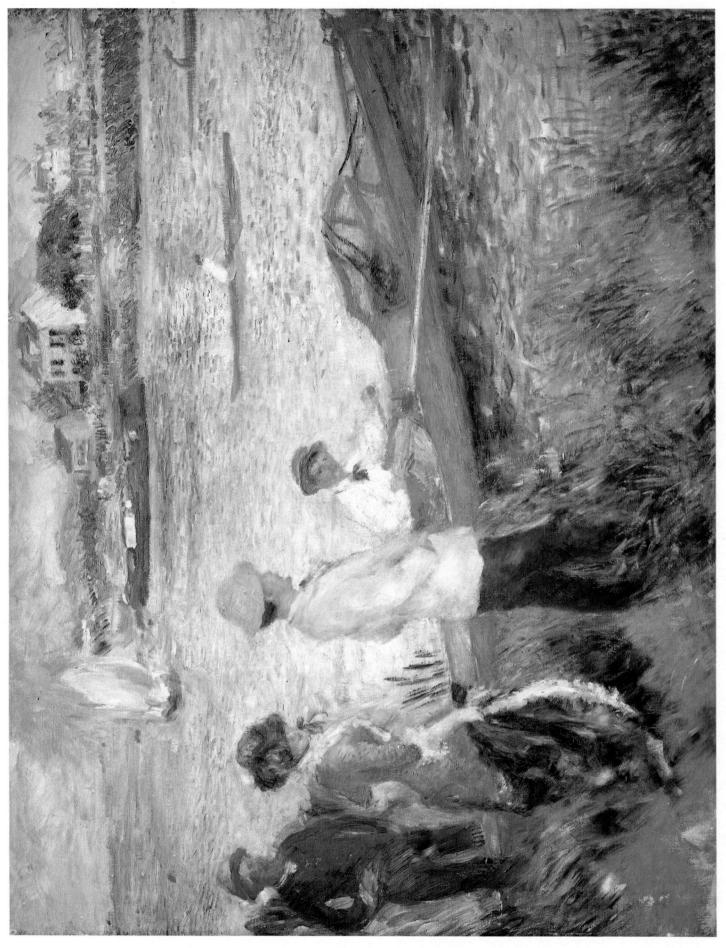

32. Oarsmen at Chatou. 1879. Washington, National Gallery of Art (Gift of Sam A. Lewisohn)

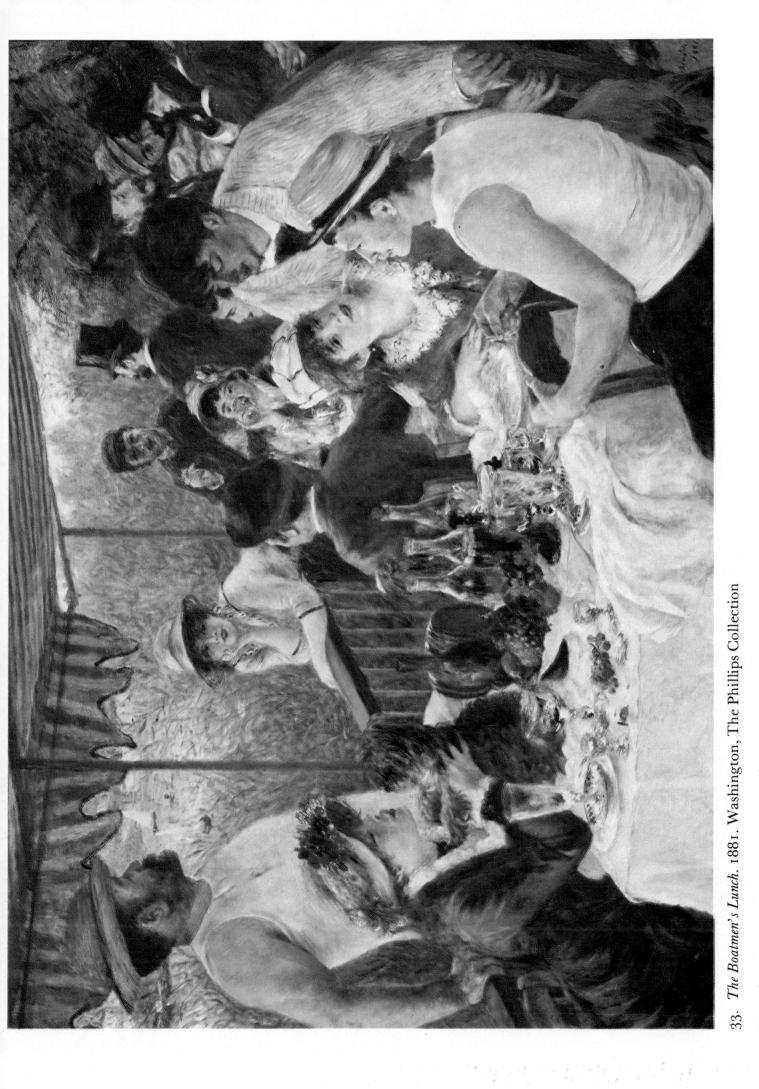

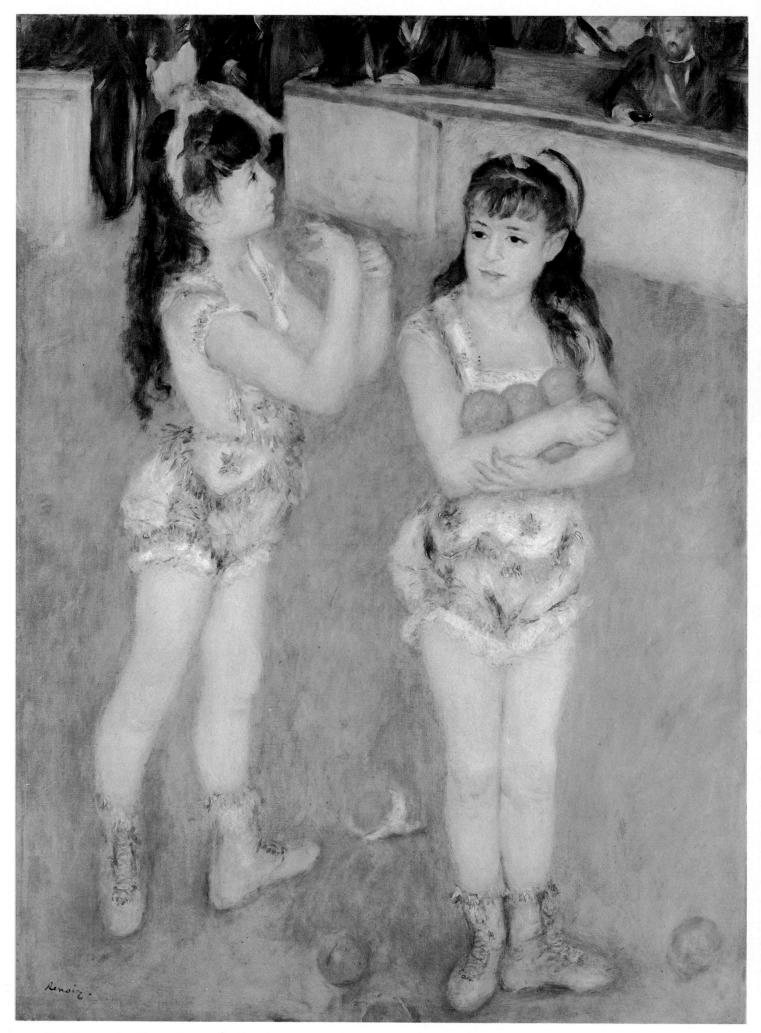

34. Jugglers at the Cirque Fernando (detail). 1879. Chicago, Art Institute

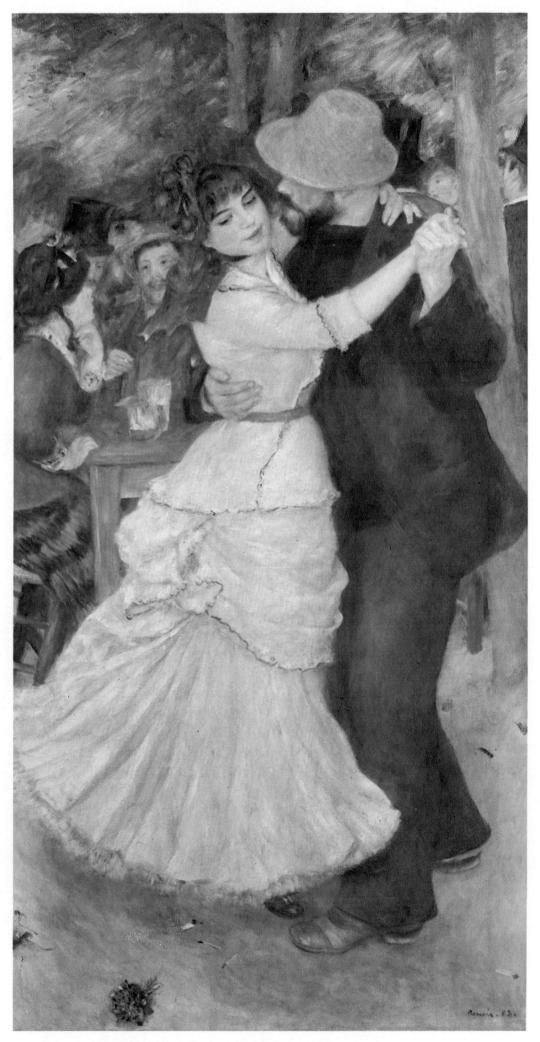

35. Dance at Bougival. 1883. Boston, Museum of Fine Arts

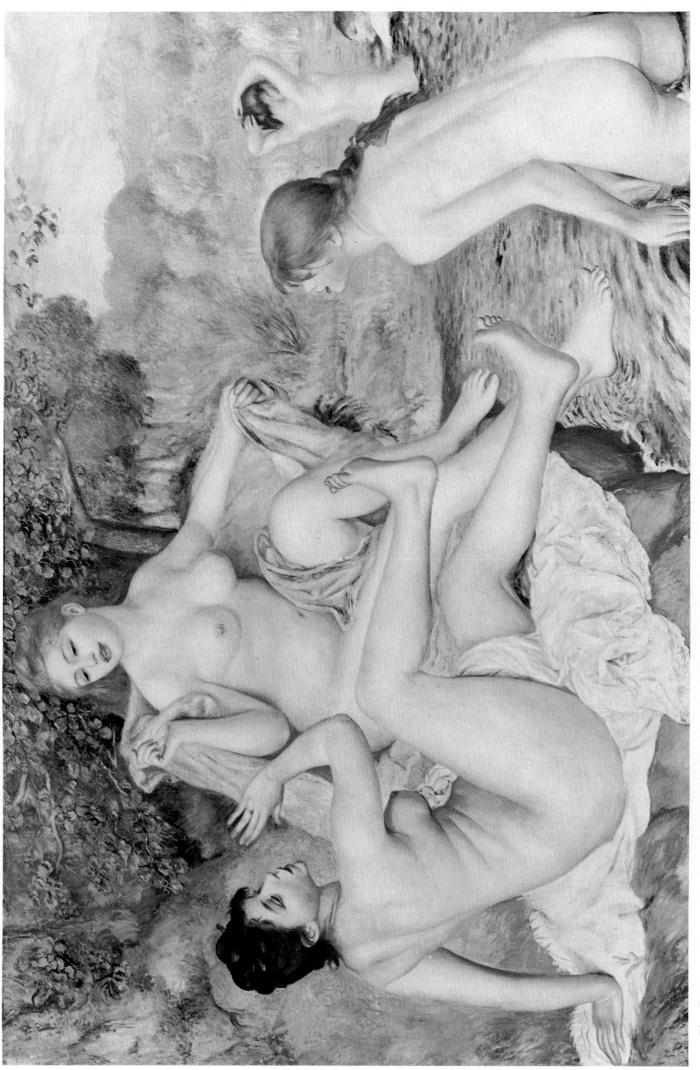

37. The Bathers. 1884-7. Philadelphia, Museum of Art (Mr & Mrs Carroll S. Tyson Collection)

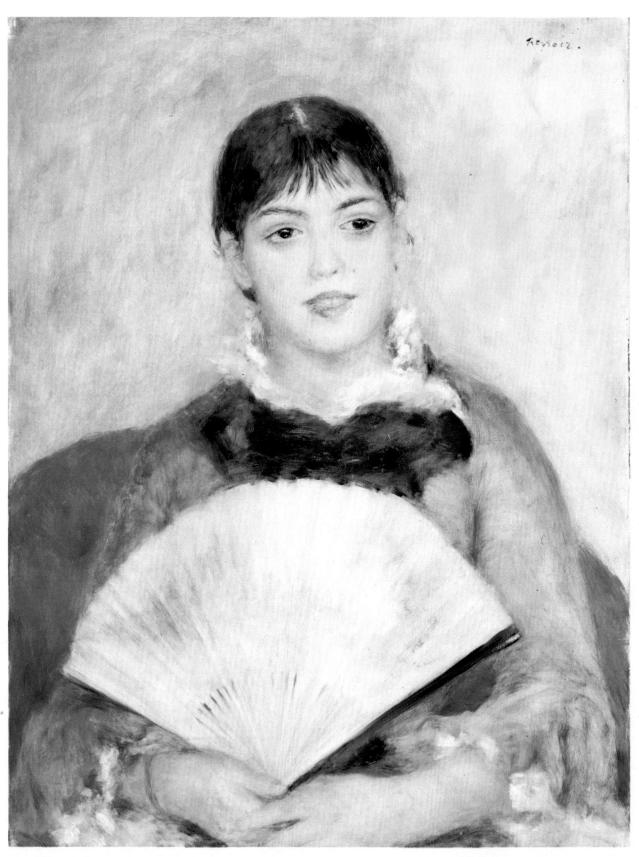

38. Woman with a Fan (detail). 1880. Leningrad, Hermitage

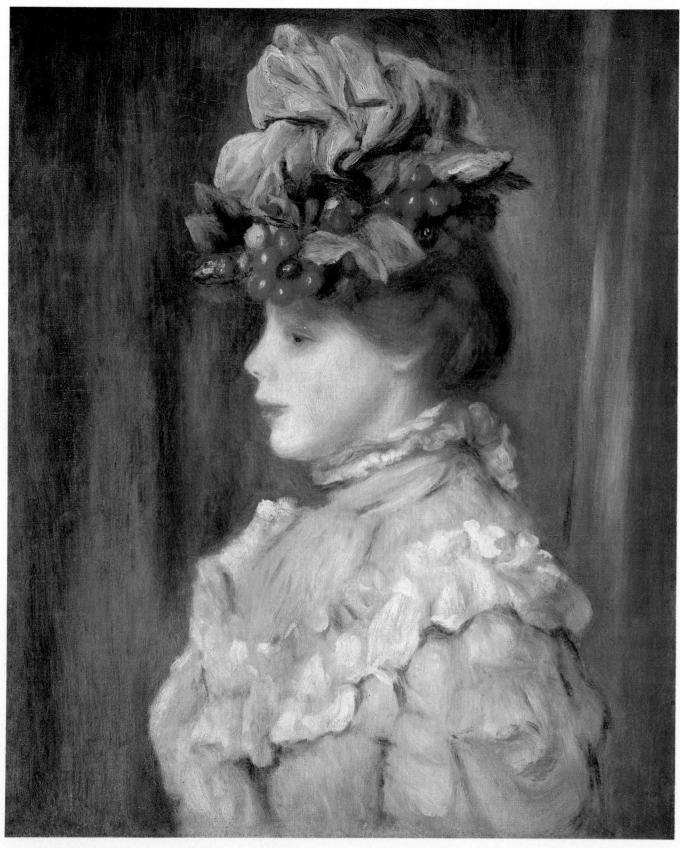

39. 'Le Chapeau à Cerises.' 1884. Private Collection

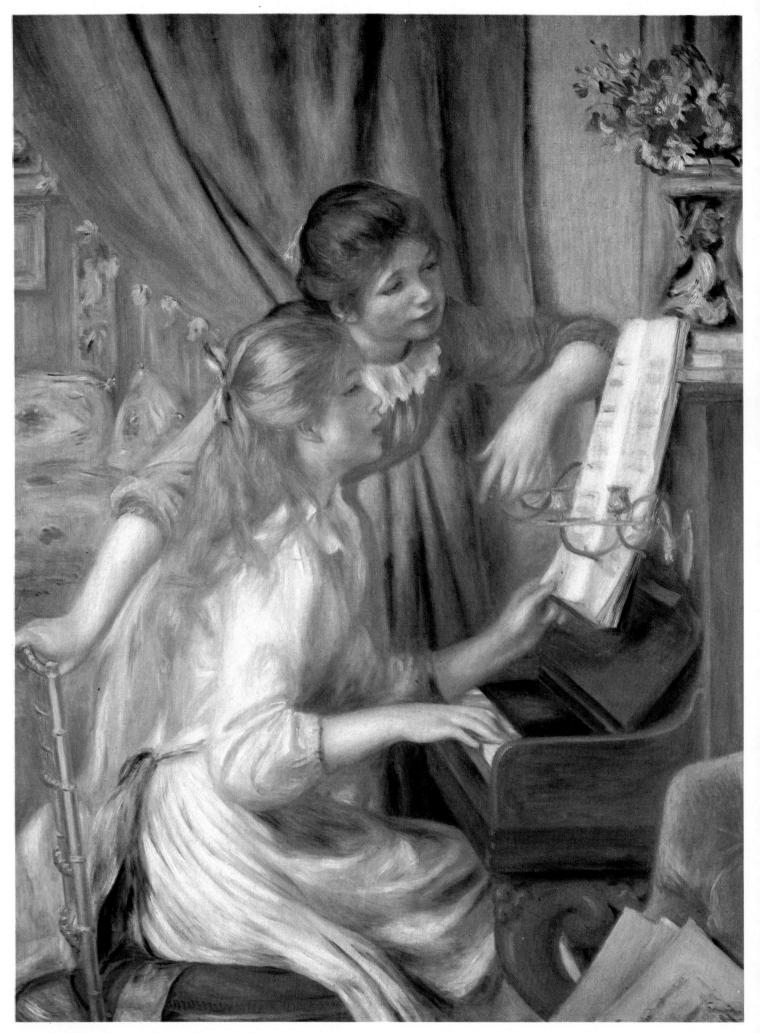

40. 'Au Piano.' 1892. Paris, Louvre (Jeu de Paume)

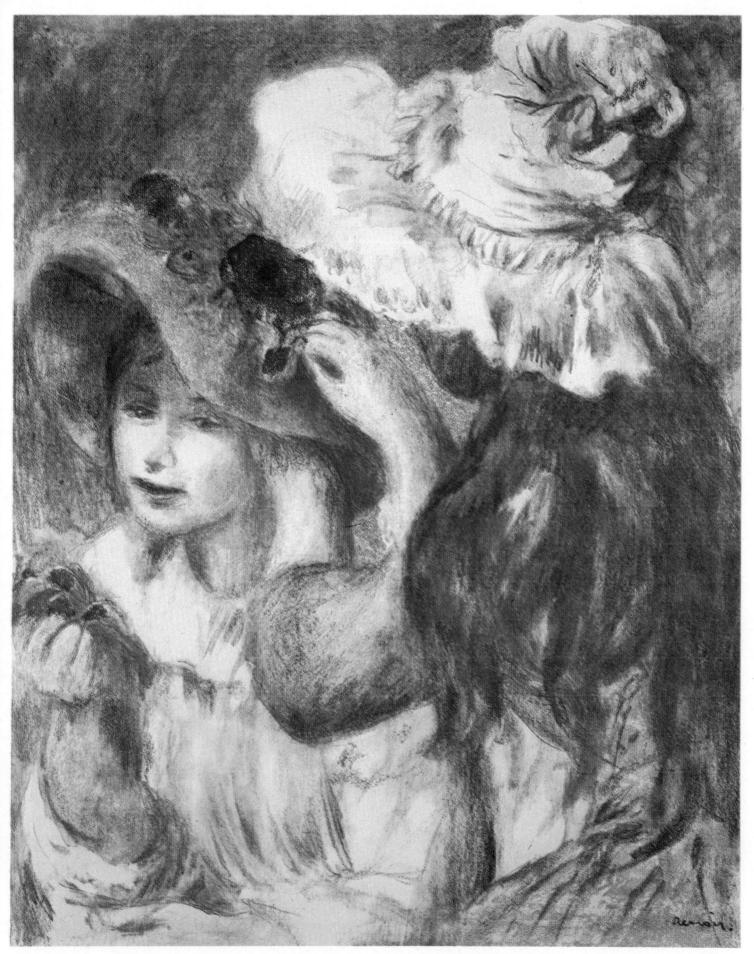

41. 'Le Chapeau Épinglé.' 1897. Ikeda, Japan, Museum of 20th Century Art

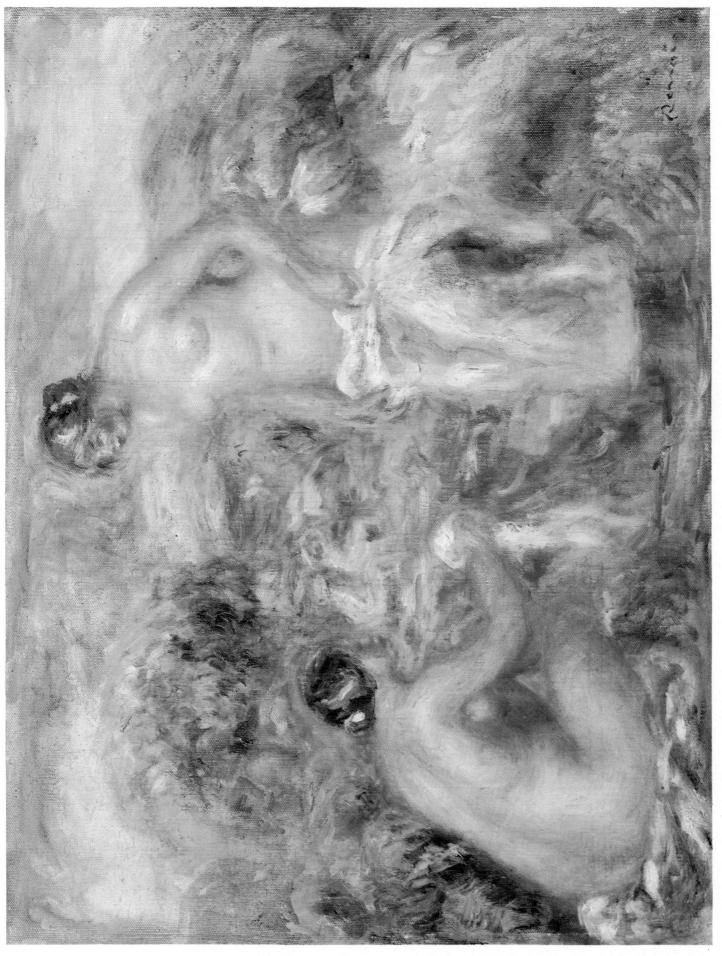

42. Nude Figures in a Landscape. 1910. Canvas, 40×51 cm. Stockholm, National Museum

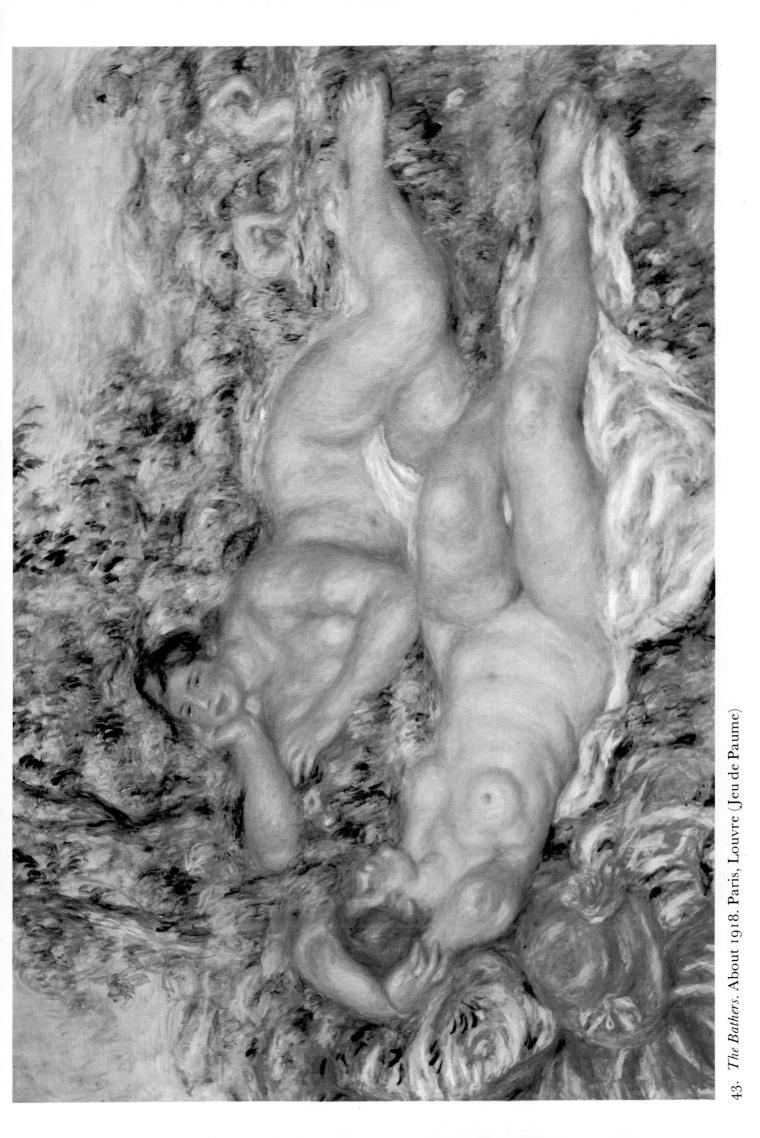

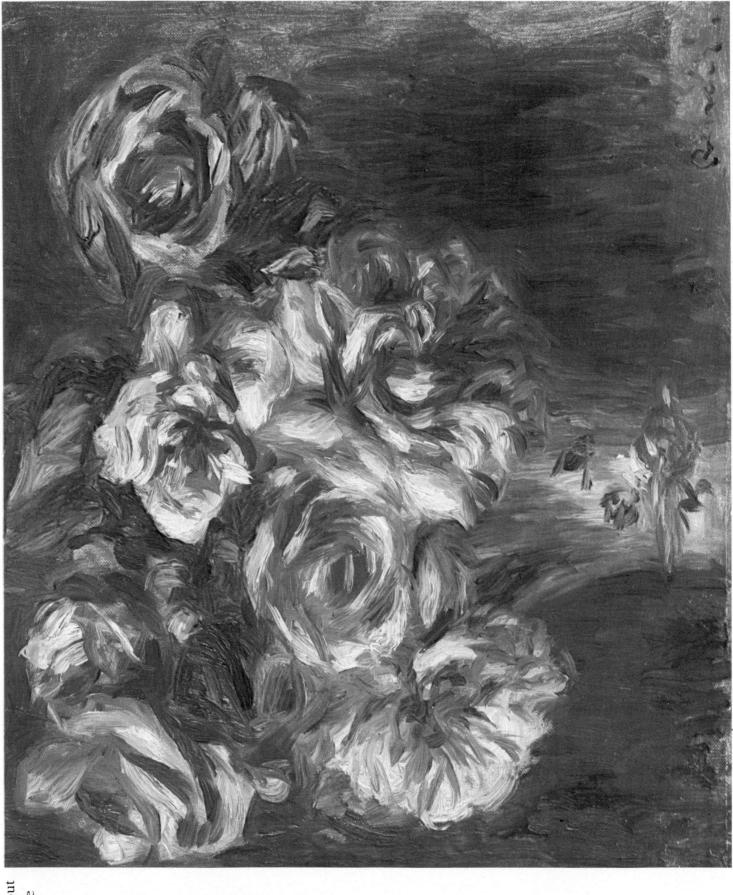

44. Roses in a Vase. About 1900. Paris, Louvre (Jeu de Paume)

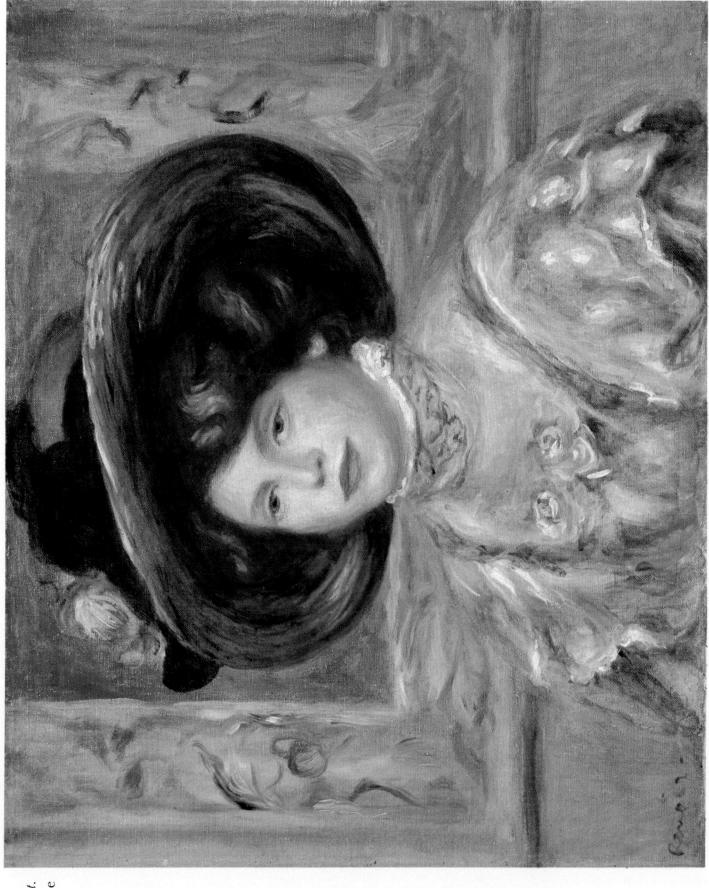

45. Portrait of a Young Woman in a Blue Hat. About 1900. Private Collection

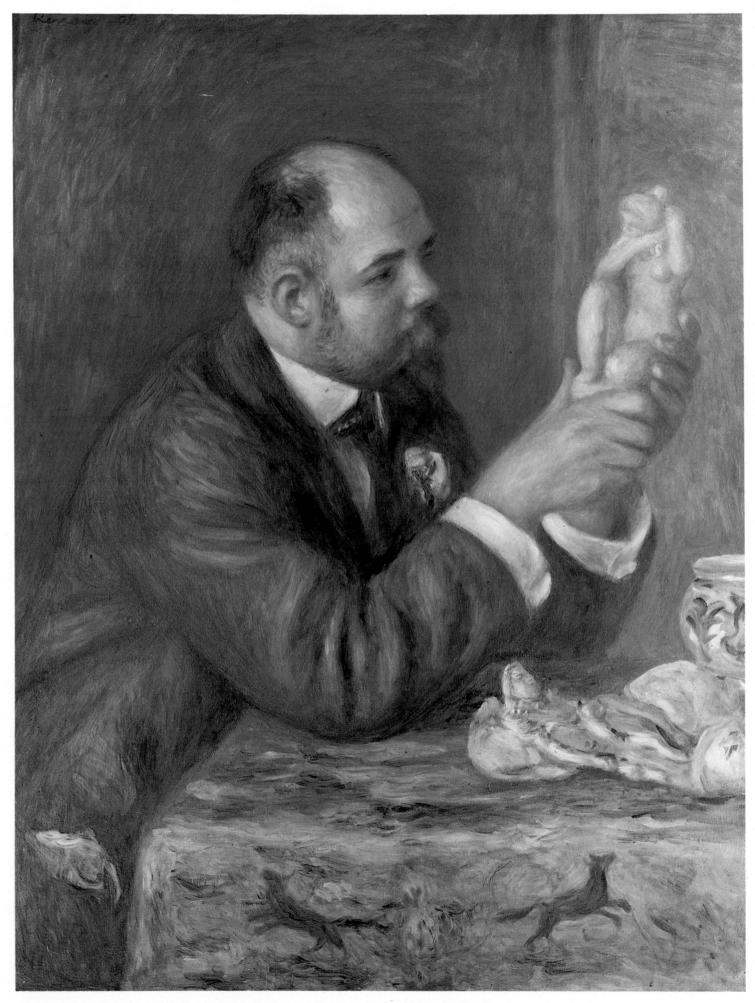

46. Portrait of Ambroise Vollard. 1908. London, Courtauld Institute Galleries

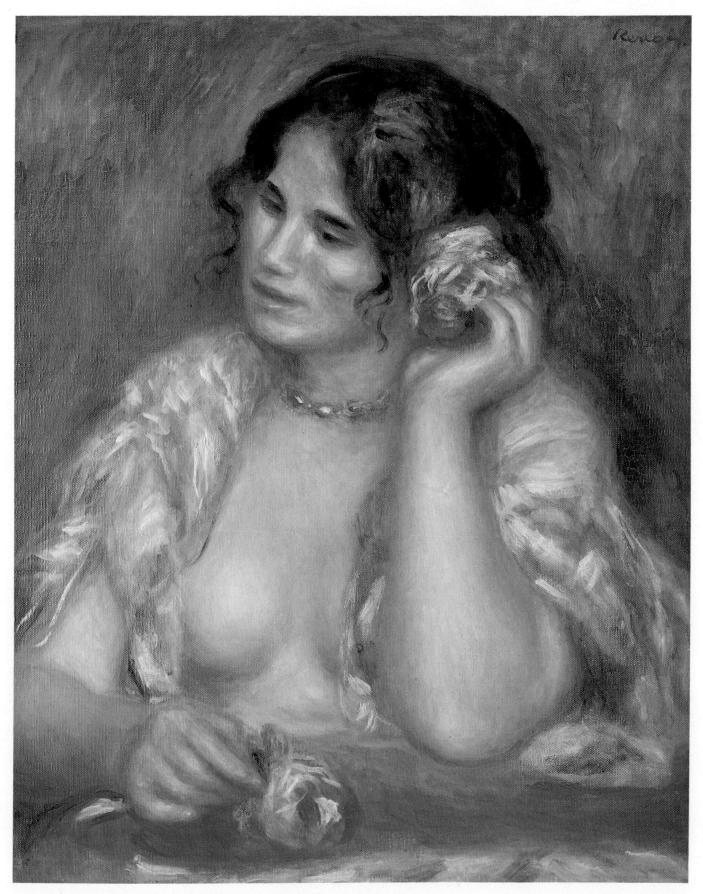

47. Gabrielle with a Rose. 1911. Paris, Louvre (Jeu de Paume)

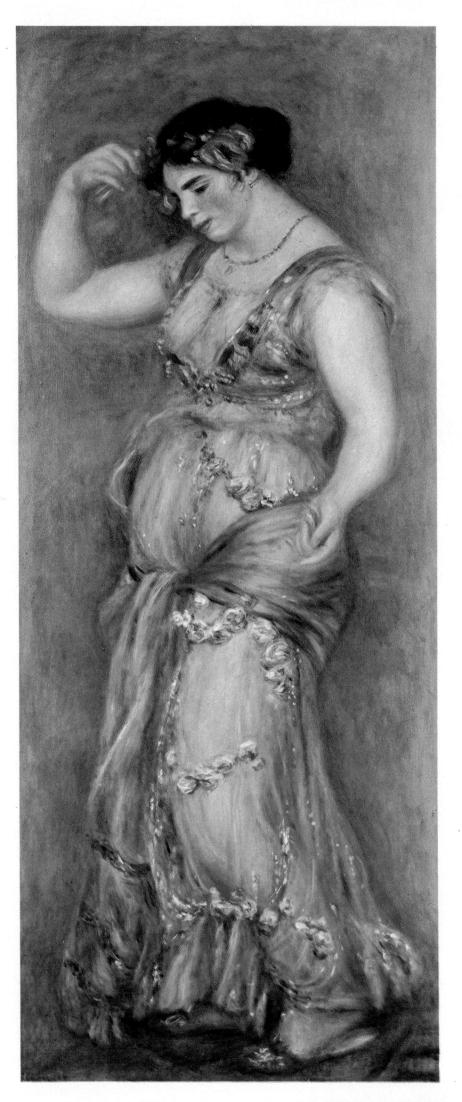

48. Dancing Girl with Castanets. 1909. London, National Gallery